Landscape

A Comprehensive Guide
to Drawing and Painting Nature

Richard McDaniel

Watson-Guptill Publications / New York

For you.

Frontispiece:
Catskill Wonderland
Oil on canvas, 30 x 44" (76 x 112 cm), 1992.

Pages 2-3:
Elysian Field #3 (detail)
Oil on canvas, 30 x 44" (76 x 112 cm), 1983.

Page 5:
China Bend
Pastel, 11 x 17" (28 x 43 cm), 1996.

First published in 1997 in the United States by
Watson-Guptill Publications, a division of
BPI Communications, Inc.,
1515 Broadway, New York, New York 10036.

Library of Congress Cataloging-in-Publication Data
McDaniel, Richard, 1948–
Landscape : a comprehensive guide to drawing and painting
nature / by Richard McDaniel.
 p. cm.
ISBN 0-8230-2592-6
1. Landscape in art. 2. Art–Technique. I. Title.
N8213.M331997
758'.1–dc21 97-9185
 CIP

Manufactured in Malaysia

First printing, 1997

1 2 3 4 5 6 7 8 / 04 03 02 01 00 99 98 97

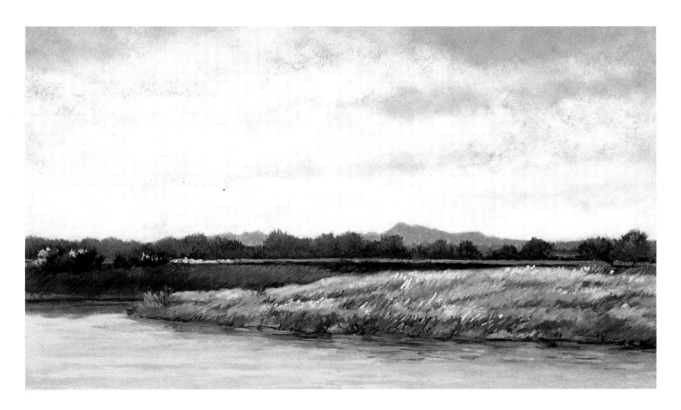

Acknowledgments

Whatever shortcomings, oversights, and unabashed lunacy may appear in this book are my responsibility alone. The good spots are due in large part to those listed below, and I take particular pleasure in thanking them at this time.

Topping the list is the staff at Watson-Guptill; their professional skills are obvious, but their kindness and enthusiasm deserve equal mention. Thanks to Marian Appellof, Robbie Capp, Ellen Greene, Wynne Patterson, Harriet Pierce, and also Candace Raney, with whom the scope of this book began to take shape one autumn afternoon over a leisurely lunch in Manhattan.

I am grateful to many for their technical expertise and product support, including Ed Brickler, Don Bozek, Larry Campbell, Sally Drew, Martha and Robert Gamblin, Pierre Guidetti, Tim Hopper, Mike and Coletta Maier, Marion Mecklenberg, Peter Ouyang, Michel Ritz, Dee Silver, Paul Solomon, Helen Vengrofski, and Kitty Wallis.

I would like to thank the various museums and galleries for providing historical landscapes, as well as the fine contemporary artists who graciously furnished examples of their artwork to this publication. Thanks, too, to those collectors of my own work who allowed it to be reproduced herein, and to the ongoing support of the John Pence Gallery in San Francisco.

Also, I extend a hearty handshake to my colleagues and fellow instructors at the Woodstock School of Art; and all players, spectators, and dogs at Wednesday Night Ping-Pong.

I am particularly grateful to my students, who taught me so much; and to the following artists with whom I've discussed the merits of landscape over the years: Albert, Barbara, Bob, Clark, Doug, Duncan, Ed, Elizabeth, Marjorie, Paul, Wayne, and Wolf.

To the others who have provided friendship, information, and emotional nourishment, I am deeply indebted. Thank you Joan, John, Linda, Louise, The Millay Colony, music, Philip, the Reiter family, Rob and Deb, Sheila, Simon, Talking Books, and Tom. Thank you, Bruce, for your cartoons and your laughter.

And finally, words alone cannot express my appreciation for my mother and father, who once again shared their wisdom, humor, and love from far away, yet were always very near.

Contents

Tree Sketch
Pencil, 7 x 11" (18 x 28 cm), 1996.

Introduction

This book is the result of countless questions. The first questions were mine, as I tried to understand why I found landscape so fascinating. I wanted to learn how to capture that fascination on canvas. Questions also came from other artists and teachers as we discussed various approaches to drawing and painting nature. Still more questions were asked by those with a genuine interest in art, but who were not artists themselves. Of course, many of the best questions came from my students who, like me, were seeking ways to convey their impressions of nature.

As I've developed my understanding of landscape from direct observation, hours at my easel, and the study of other artists' work, I've discovered methods that are best for me. They are surely not the only way; there is no one way. But I am happy to share what I've learned in hopes that this information will help you find your *own* way, with alacrity and a minimum of wasted time.

Above all, I wish to impress upon you that theory and technique are only a means to an end, not substitutes for inspiration and creativity.

While many working procedures are common to portraits and still life as well as to landscapes, certain aspects of landscape art are unique. They are covered within these pages, but to summarize them here: Deep space, effects of atmosphere and varying weather conditions, changing natural light, and unlimited boundaries all present challenges as well as rich inspirational material. Additionally, when forms are seen in the distance or affected by inclement weather, they become less distinct, a naturally occurring alteration that allows the landscape artist to create simple, abstract compositions while remaining faithful to visual reality.

Finally, there is the added exhilaration of working outdoors. Have you noticed how often people feel rejuvenated after a trip to the country? Nature seems to put things in perspective. *Painting* nature amplifies these feelings—known so well by artists passionately devoted to portraying the natural world. True, the challenges of drawing and painting nature are numerous, but landscapists seem to enjoy the struggle. In fact, we take pride in it.

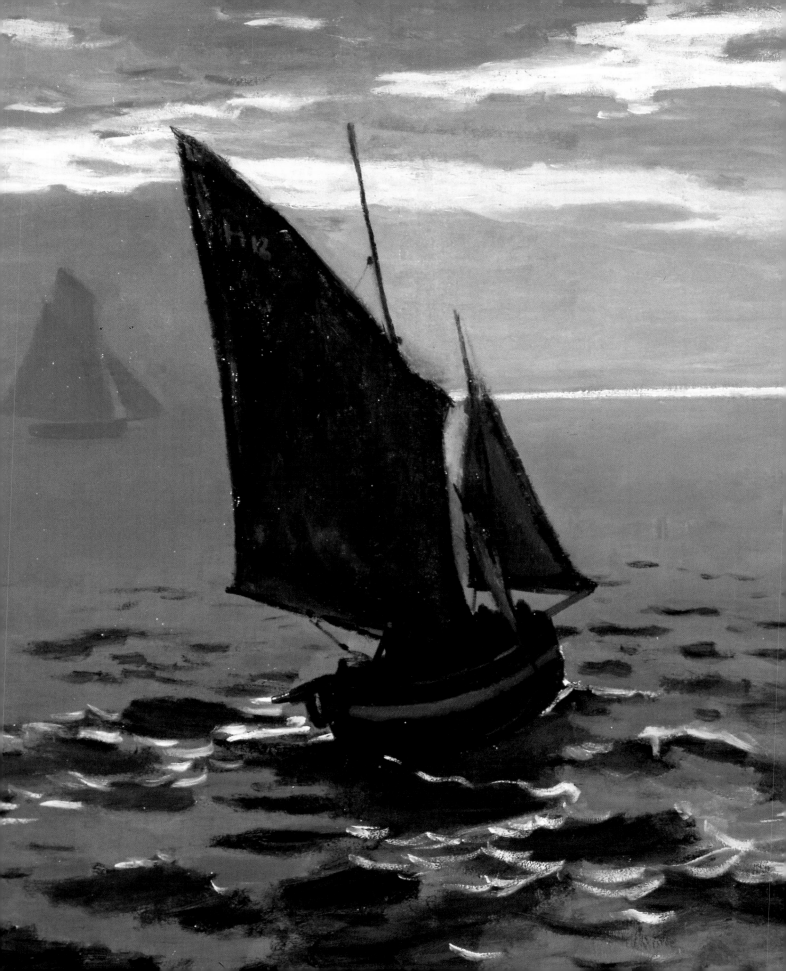

A Brief History of Landscape Painting

If you are a landscape painter, you are part of a noble tradition. Landscape painting is a serious art form, the outgrowth of human awareness and artistic sensitivity. It is the result of a lengthy creative evolution: a companion to humankind's ever-changing outlook toward the natural environment.

The desire to portray nature—or the feelings associated with nature—can take many forms.

To some, the quest involves realistically transcribing a majestic vista or showing the elusive qualities of sunlight.

To others, the natural world serves as a point of departure, inspiring expressive landscapes that provide a glimpse into the artist's psyche as well.

Claude Monet
Detail, *Boats Leaving the Harbor at Le Havre* (page 16)
Oil on canvas, 38^1/16 x 51^1/8" (97 x 130 cm), 1865.
Hill-Stead Museum, Farmington, Connecticut.

And to many, nature painting is seen as a metaphor, as a search for spiritual or ecological truth.

Throughout history, landscape images have been linked with ritual, mysticism, religion, and philosophical thought. No doubt landscape elements were used in ancient drawings and paintings (the Roman murals from Pompeii, before the eruption of Vesuvius in A.D. 79, are one example), but little remains for our study.

We must therefore limit our discussion to the art of the last thousand years, which should nonetheless be an ample time span to get a basic sense of the landscape tradition.

Our historical survey will begin in the East.

Although depictions of the countryside had been enjoyed by the Chinese for centuries, it was the work of the artist/scholars at the Sung court, inspired by the emperor himself, that marks the zenith of early landscape painting.

Historical Antecedents: A Survey

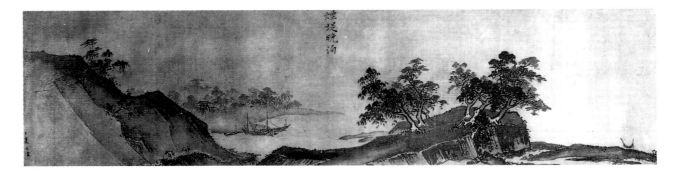

Hsia Kuei
Detail, *Twelve Views of Landscape*
Ink on silk handscroll, 11 x 90³/4" (28 x 231 cm) (overall),
c. 1220–1250. The Nelson-Atkins Museum of Art, Kansas
City, Missouri. (Purchase: Nelson Trust.)

Chinese artists of the Sung Dynasty (960–1279) elevated landscape painting to a new level of skill and popularity. Tied to religious attitudes, a respect for nature, and aspects of meditation, landscape painting became an outward expression of inner peace.

And in Japan, during the Kamakara Period (1185–1333), Zen monks encouraged the trend. Since the Zen believer sought intimacy with nature and a oneness with the physical world, it followed that landscape images would be spiritually acceptable subject matter for painting as well as poetry.

However, the emergence of landscape as an independent theme did not occur in Western art until the late sixteenth century. While some paintings dating back to Roman times contain pastoral details, such elements were simply descriptive backdrops, subordinate to portraiture and narrative depictions.

Through the Middle Ages, religious concepts led to the rejection of pure landscape painting, for fear that earthly manifestations would divert mankind from pious thoughts; images of nature might be the devil's bait for sensuous distraction. But not all devout Christians held this view. One such voice in the wilderness belonged to Saint Francis of Assisi (1182–1226). He es-

poused a philosophy in which religious teachings were celebrated through a gentle harmony with nature. Although these ideas would not gain ascendancy for centuries, their basic concepts slowly began to take root.

Renaissance painters, for all their interest in perspective and direct observation, still considered landscape as an ancillary component for supplying factual details. Leonardo da Vinci (1452–1519) and Albrecht Dürer (1471–1528), for example, explored landscape with a scientific, rather than a solely artistic, interest. Although they created sensitive studies of nature, these were primarily sketches of isolated details.

The most common Renaissance application of landscape imagery was the "view out the window," employed as a descriptive comment, and frequently as a symbol of prestige in the portrait of a wealthy landowner. At times, though, landscape was used as a structural aid to composition, foreshadowing its future role in the development of abstraction. A tree, for

example, could be placed in any part of a painting that needed an element to balance the design.

The intellectual liberation of the Renaissance was at first focused upon the mortal soul and the human form. Only when artists and other thinkers had thoroughly and religiously explored the human figure did they feel sufficiently free to adopt a wider view of divine nature—a view that began to concentrate on the vastness of landscape as an individual subject.

The sixteenth-century Italian painter Annibale Carracci (1560–1609) portrayed people as typically minor forms in his hunting and fishing scenes. The paintings of Salvator Rosa (1615–1673), Nicolas Poussin (1594–1665), and other seventeenth-century Classicists often included the human figure as a subordinate element, with religious or mythological narration providing a convenient justification for creating the deep space and atmospheric environment of a landscape.

Seventeenth-century Dutch landscapes often featured low horizons and expansive skies, with all evidence of humankind dominated by the boundless embrace of the heavens. Gradually, nature painting gained wider status through the works of Rembrandt van Rijn (1606–1669) and Jacob van Ruisdael (1628–1682) in Holland, and Peter Paul Rubens (1577–1640) in Flanders. Landscape ceased to be treated as merely background and was finally acknowledged as comparable to religious, historical, and portrait painting.

With the dawning of the Romantic era in England and Protestant Europe, legions of writers and artists endowed nature with religious significance. They

Salvator Rosa
Landscape with Herdsmen
Oil on canvas, 29^1/2 x 39^1/2" (75 x 99 cm), c. 1661. Frances Lehman Loeb Art Center, Vassar College, Poughkeepsie, New York. Gift of Mrs. William Levitt (Janice Loeb, class of 1935).

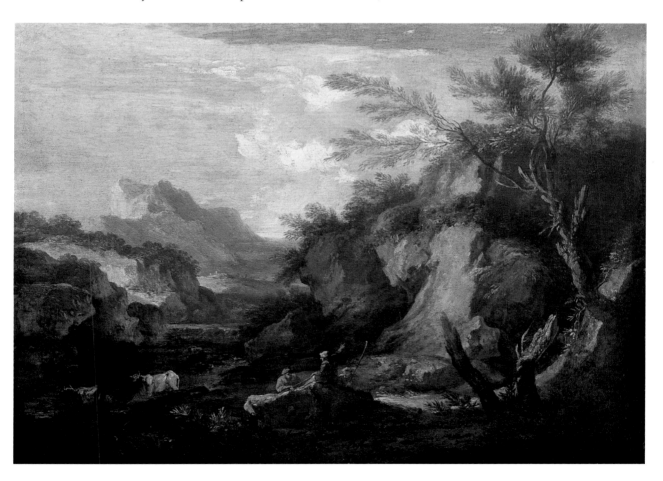

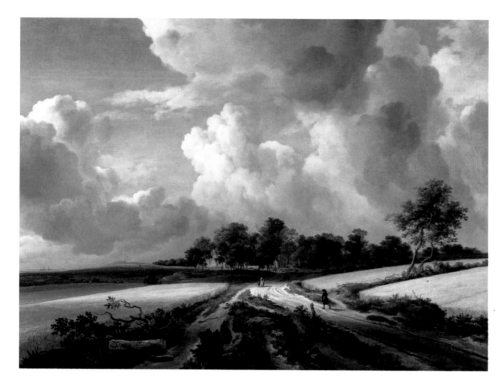

were convinced that the sublime evidence of God's omnipotence was best conveyed through the sylvan motif of landscape. They exalted primitive country life, viewing nature as divine. This outlook is well described by Ludwig von Beethoven, whose liner notes to his Pastoral Symphony describe emotions expressed "that are aroused by the pleasures of the country, or in which some feelings of country life are set forth."

John Constable (1776–1837) and other English painters began taking their easels out into the open air at the start of the nineteenth century. J. M. W. Turner (1775–1851) was fascinated by the tumultuous and stormy aspects of nature. At times considered overly dramatic, his work nonetheless represents a desire to paint light, and presages the liberation of color to come later in the century.

Ultimately, Romanticism was replaced by Realism, with its more objective reporting of the natural world. Gone was the pious undertone, yet landscape still evoked a sort of spirituality. While Gustave Courbet (1819–1877) and Jean-François Millet (1814–1875) waved the banner of Realism and painted workers, peasants, and everyday subjects with compassion, it is the French group known as the Barbizon painters who are remembered most for their advances in landscape painting. Jean-Baptiste-Camille Corot (1796–1875), along with Théodore Rousseau (1812–1867) and Charles-François Daubigny (1817–1878), was one of the masters of the Barbizon School at Fontainebleau. With a palette limited for the most part to earth tones and muted colors, he created canvases with solid form and clearly defined areas of light and shadow.

Corot and his contemporaries did not break completely with academic tradition but certainly chafed under the conventions of the old guard. The Realists and the Barbizon painters revolted against the "dignified" subject matter of the academies, in favor of the more humble motifs of peasant life and pastoral themes. They began to emphasize a directness, or sketchiness, in their work, simplifying forms and concentrating on the overall effects of natural daylight.

The introduction of the metal paint tube in 1840, and then improvements in the portable easel, brought about a dramatic change in the habits of landscape painters. As outdoor painting became less burdensome, and artists created more and more paintings in the field, they discovered new information about lighting. Previously, when landscapes were completed in

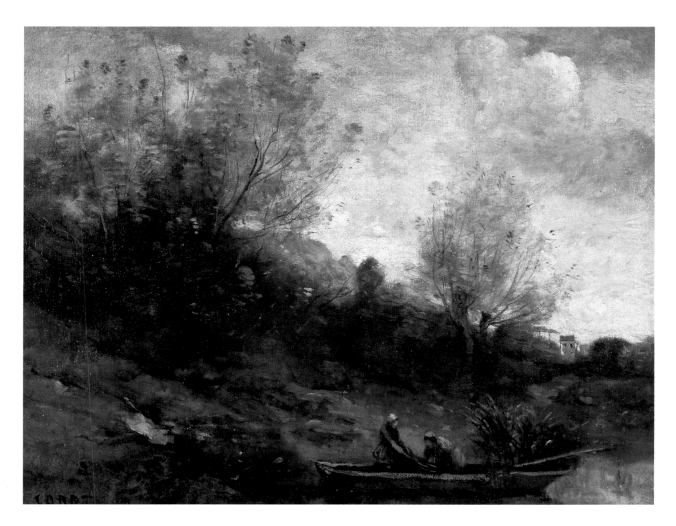

Jean-Baptiste-Camille Corot
Pêcheurs en Barque au Bord de la Rive
Oil on canvas, 15³/8 x 18⁵/8" (39 x 48 cm), c. 1865.
Frances Lehman Loeb Art Center, Vassar College,
Poughkeepsie, New York. Gift of Mrs. Avery Coonley
(Queene Ferry, class of 1896).

the studio, artists were accustomed to the cool light and warm shadows that prevailed in academic painting. However, the light outdoors is quite different. Objects bathed in sunlight are *warm* in color, while shadows (illuminated by the reflected blue light of the sky) are actually cool.

The effects of atmosphere and changing light proved increasingly important, eventually providing a major impetus for the Impressionists. New materials, color theory, social and political attitudes, even the influence of Japanese prints and photography—all contributed to the rise of Impressionism, but nothing so much as the light itself. Artists such as Claude Monet (1840–1926), Berthe Morisot (1841–1895), Camille Pissarro (1830–1903), Pierre-Auguste Renoir (1841–1919), and Alfred Sisley (1839–1899) painted out in the open air with intense colors and gestural brushwork.

Monet, in particular, remained an ardent proponent for working outdoors in front of the motif. He painted in all seasons and weather conditions, with little regard for comfort, in an effort to capture the fleeting effects of nature. One of his primary goals was expressing the quality of light in the open air. It was, and continues to be, one of the greatest challenges in art.

The first Impressionist exhibition took place in 1874, and the last in 1886. In those twelve years, the work had tremendous impact on the art world. Although

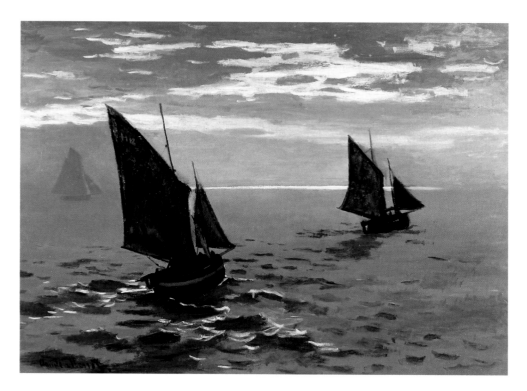

Claude Monet
Boats Leaving the Harbor at Le Havre
Oil on canvas,
38^{1}/16 × 51^{1}/8"
(97 × 130 cm), 1865.
Hill-Stead Museum,
Farmington,
Connecticut.

Impressionism was not universally admired, it did gain a degree of acceptance. More important, it opened the door for the succeeding waves of abstraction.

Vincent van Gogh (1853–1890) and Paul Cézanne (1839–1906) were both influenced by their association with Impressionist painters, but each evolved through experimentation to his own mature style. As a painter of nature, van Gogh often imitated the direction of plant growth with his brushstrokes, developing a sort of personal shorthand for describing what he saw and felt. His passionate, heavily textured work can be seen as a precursor to the agitated images of the German Expressionists, the Fauves, and later, to the Abstract Expressionists of the mid-twentieth century.

Cézanne, sometimes called the "Father of Modern Art," applauded the brilliant color of the Impressionists but thought their work lacked structure. Was faithfully painting nature enough? What about design? Cézanne sought a new solidity in his forms, but with the liberated color of the Impressionists. He wanted to paint depth without the loss of brightness, order without the loss of depth, and nature without the loss of design. His systematic examination of form and space signaled another new direction, ultimately paving the way for the analytical cubism of Pablo Picasso (1881–1973) and Georges Braque (1882–1963).

Several masters of modern art, such as Piet Mondrian (1872–1944) and Wassily Kandinsky (1866–1944), cited landscape as a major influence, both pictorially and spiritually. Mondrian, known for his supremely austere compositions, painted his way through a variety of styles during his creative exploration. His growth through Impressionism, Fauvism, and Cubism can be tracked in a series of landscapes that reveal his patient search to reduce the diversity of nature to the plastic expression of basic geometric shapes.

Kandinsky, along with Paul Klee (1879–1940) and Franz Marc (1880–1916), responded to nature in an organic, passionate style, creating an Expressionistic movement known as Der Blaue Reiter (The Blue Rider). They displayed a body of work that was intensely colored, abstracted, and idealized. It was also an apocalyptic foreshadowing of the impending world wars. The artists shared a pantheistic concern with the chaos brought about by human follies, and pointed to a better world through their art—a world in which animals were inseparable from the landscape. The paintings of Franz Marc were an impassioned plea for a

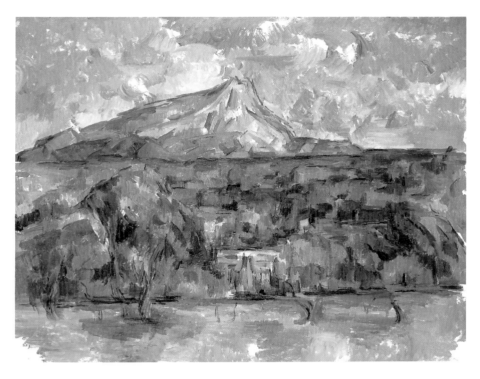

Paul Cézanne
Mont Sainte-Victoire
Oil on canvas, 25 1/8 x 32 1/8"
(64 x 82 cm), 1902–1906.
The Nelson-Atkins Museum of
Art, Kansas City, Missouri.
(Purchase: Nelson Trust.)

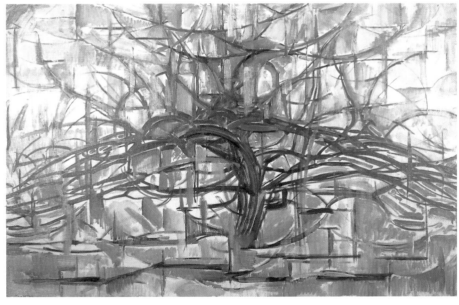

Piet Mondrian
Horizontal Tree
Oil on canvas, 29 5/8 x 43 7/8"
(75 x 111 cm), 1911. Munson-
Williams-Proctor Institute,
Museum of Art, Utica, New
York.

return to innocence by an artist whose life was ironically cut short on the battlefield of Verdun in 1916.

It is unfortunate that much of the positive spirit that propelled landscape painting was engulfed in the vortex of catastrophe as two world wars ripped through the Continent, halting many idyllic dreams of nature and replacing them with nightmares and sad resignation, even with streetwise cynicism. Is it any wonder that the tragedy of war ushered in Dada and other movements focused upon nonsense and non-art, and that artists turned their attention inward, extracting images from intellectual precepts rather than the physical beauty of the landscape?

In America, landscape painting took a separate yet

somewhat parallel path to that of Europe. Much of early United States history concerned the settlement of the American continent, the New World. Hence, the American countryside was intimately connected to the self-image of a youthful nation. As the population ventured out into the wilderness, the expansive landscape became a metaphor for the abundant resources of American dreams.

Nineteenth-century artists such as Thomas Cole (1801–1848), Jasper Cropsey (1823–1900), and Frederic Edwin Church (1826–1900) infused their Hudson River landscapes with a combination of spiritual reverence and direct observation of nature. Westward expansion, traces of Romanticism, and a nationalistic pride in the newly independent United States provided painters with the political and philosophical momentum for exploring vast regions of America, extolling the majesty of her landscape.

After the Civil War, American landscapists looked in two directions: territorial expansion lured Albert Bierstadt (1830–1902), Thomas Moran (1837–1926), and others to paint in the West, while the French Barbizon School had its own effect on those who remained in the East. Noteworthy among those painters who combined French influences with American scenes and attitudes was George Inness (1825–1894). His Luminist images earned him a reputation as one of this country's foremost landscape painters.

Many Americans felt their art education incomplete without studying in Europe. The novel ideas of

Frederic E. Church
Morning, Looking East Over the Hudson Valley
from the Catskill Mountains
Oil on canvas, 18 x 24" (46 x 61 cm), 1848.
Albany Institute of History and Art. Gift of Catherine Gansevoort Lansing.

Frederic Church painted this view from the Catskills shortly after the death of his friend and teacher, Thomas Cole, the artist who launched the Hudson River School.

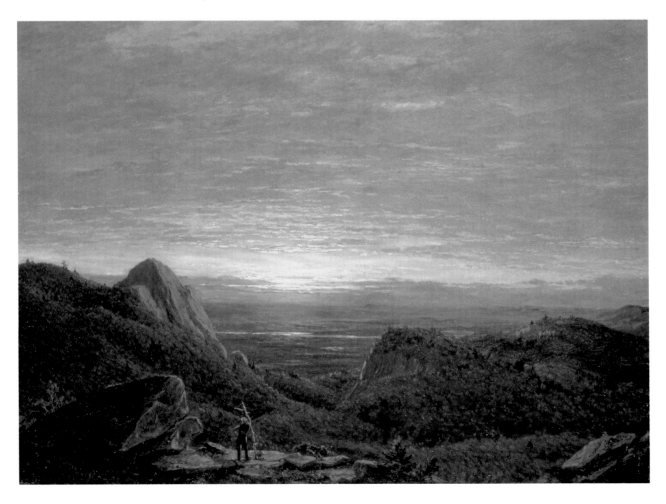

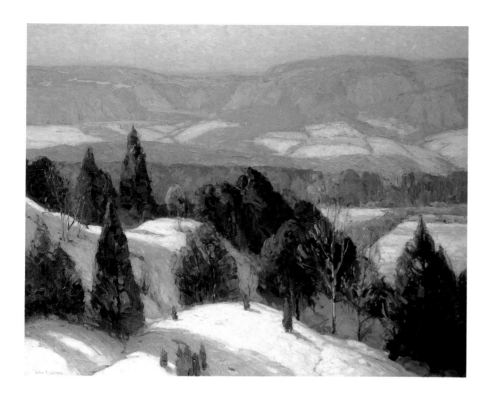

John F. Carlson
Templed Hills
Oil on canvas, 40 x 50"
(102 x 127 cm), after 1920.
Courtesy of John Pence Gallery,
San Francisco.

Impressionism were brought back across the Atlantic, where they were well received. In fact, Americans were the first major patrons of French Impressionist art. It is therefore no surprise that a significant branch of landscape painting, American Impressionism, developed here. Artist colonies throughout the United States were populated by a number of prominent painters, each working from the American landscape out in the open air.

William Merritt Chase (1849–1916) was an influential teacher at Shinnecock, Long Island, as was Childe Hassam (1859–1935) in Old Lyme, Connecticut. Other artists, including John Twachtman (1853–1902) and J. Alden Weir (1852–1919), also worked along the Atlantic coast, inspiring many followers. Provincetown, Massachusetts, and New Hope, Pennsylvania, established art communities dedicated to painting from nature. And in the Catskills, at Woodstock, New York, a long tradition of landscape painting began with Birge Harrison (1854–1929) and John Carlson (1874–1945) nearly a century ago. Many of these colonies still flourish today as homes for serious landscape painters and as sources of instruction for those who wish to learn in such an environment.

As the twentieth century progressed and abstraction became increasingly dominant, landscape played less of a role in American art. It was not dead; it just didn't get quite as much attention. A group of regionalist painters, Grant Wood (1892–1942) and Thomas Hart Benton (1889–1975) among them, produced work of distinctive personality, praising rural America and the virtues of a simple life. Georgia O'Keeffe (1887–1986) and Arthur Dove (1880–1946) abstracted elements from nature and incorporated them into highly personalized styles of painting. Their work exhibited a blend of abstract sensibilities and a vocabulary of landscape components.

By mid-century, most of New York, having wrested the mantle of "world art center" from Paris, had turned to abstraction. On the West Coast, however, a group of artists experimented seriously with nonrepresentational painting but then moved back in the direction of figurative work. The dynamic brushwork of Elmer Bischoff (b. 1916) and Richard Diebenkorn (1922–1993) maintains a kinship with "action painting," yet seems to have been bathed in the uplifting California brightness. Diebenkorn's work, especially, moved to a tenuous balance between modern abstraction

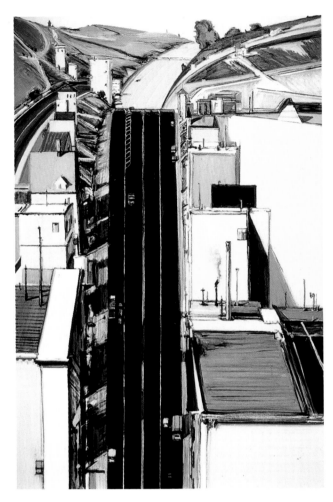

Wayne Thiebaud
Steep Street
Oil on canvas, 72 x 36" (183 x 92 cm), 1980.
Private collection.

Richard Diebenkorn
Studio Window, Ocean Park
Oil on canvas, 84 x 72" (214 x 183 cm), 1970.
Courtesy of Acquavella Galleries, New York.

and a reverence for the light and space of landscape. His *Studio Window, Ocean Park* harks back to Renaissance landscape concepts of the view out the window, yet retains a modernist flatness. It does, however, suggest an explanation for some of the angles and shapes in his Ocean Park series.

Currently, there are many methods of landscape painting, and nearly all are legitimate, at least in intent. While some artists try to resuscitate the styles of years past—often with a new poignancy—others seek fresh avenues and their own personal systems for painting nature. The cityscapes of Wayne Thiebaud (b. 1920) eloquently display the interplay of color and shape befitting the concepts of pure abstract painting, yet are loaded with the tensions of deep (and steep) space so much a part of the landscape tradition.

With the work of Wolf Kahn (b. 1927), luminous transparent color becomes as much a subject as any particular landforms, yet nature is the catalyst for his paintings. He sees the landscape simply, and paints it simply, recording his impressions in masses of color with subtle transitions of hue and value. In so doing, it becomes possible to mold elements from nature into compositions charged with chromatic light.

Today, landscape is alive and well, although not at the forefront of any avant-garde. But it has survived through enthusiastic approval and critical disfavor, and remains a viable subject for artistic expression.

In many ways, landscape art is the ultimate arena for creative exploration, partly because it resonates with universal organic instincts, and partly because, on a purely formal level, it places an abundance of images and space at the landscape artist's disposal.

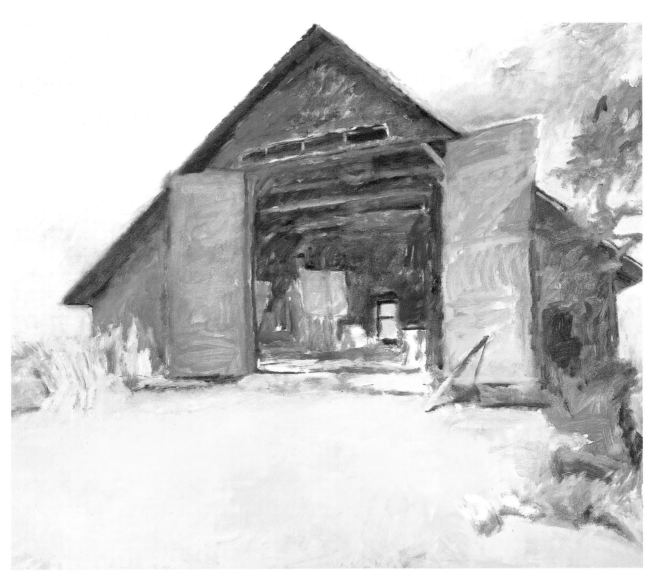

Wolf Kahn
Open Studio
Oil on canvas, 54 x 60" (137 x 152 cm), 1983.
Collection of Diane L. Ackerman.

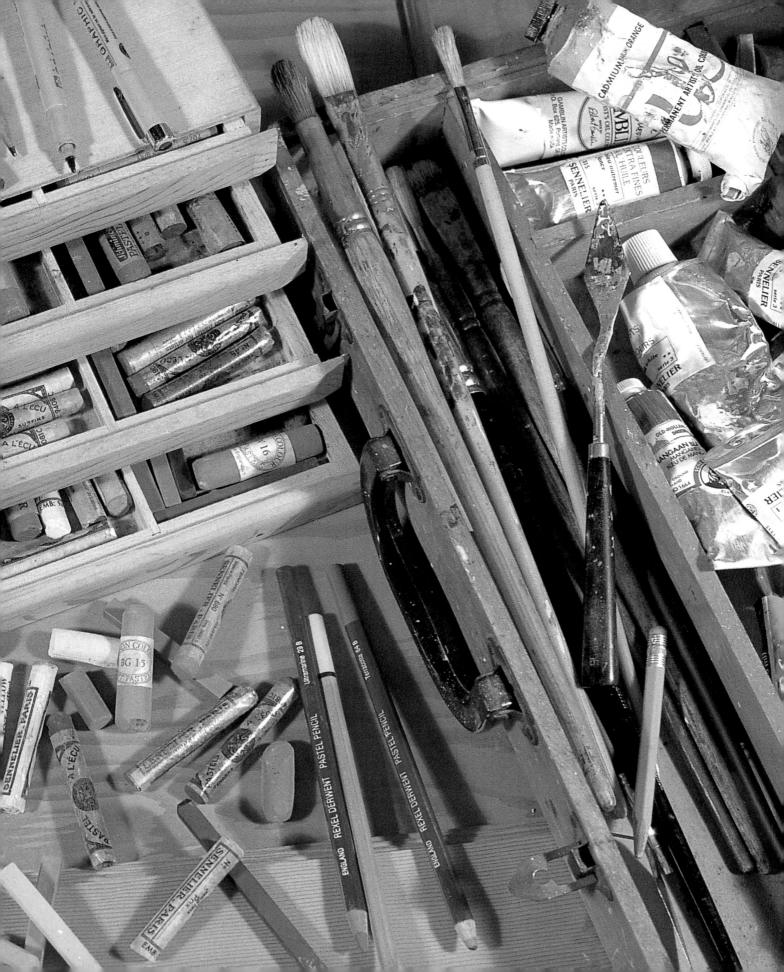

Materials

All artists should understand which materials to use to insure the quality and permanence of their work. But while it's wise to have a working knowledge of art materials, it isn't necessary to become a chemist to paint or draw well.

In selecting materials, sensibly balance cost, availability, and product standards. Just as it's possible to err in using inferior materials, it's equally wrong to insist on only the most expensive archival products when your pocketbook cannot stand the strain. Beware of getting caught up in the nervous study of supplies to the exclusion of cultivating artistic thought, being open to new creative avenues, and, above all, *doing the artwork*.

Art is learned by making *many* drawings and paintings; early works are byproducts of the learning process. Then, as the artwork gets better and better, permanence becomes a point to consider. Artists learn about the stability of materials gradually. Books can be a valuable resource, and you can also learn about materials from other artists, but this knowledge must be combined with your own hands-on experience. So roll up your sleeves and try a variety of products. Familiarity with the countless art materials available will also add to the range of techniques at your disposal.

The choices of materials that I discuss are those that work well for me, through the trial and error of learning and teaching experience. If you already have your favorite brushes, paints, and other supplies, they are probably just fine. You may choose to augment your materials with some that I mention, but don't consider my suggestions absolute or total. I haven't attempted to list every suitable brand of art supply that's available. You'll benefit by doing some research on your own to discover which materials work best for you.

Shown at left are some of my favorite
drawing, painting, and pastel supplies.

Drawing Materials

The marketplace offers an incredible array of drawing materials. For a thorough review of classic and contemporary supplies and how to use them, I refer you to my previous book published by Watson-Guptill, *The Drawing Book: Materials and Techniques for Today's Artist.*

For now, I shall concentrate on a few of my favorite materials for drawing landscape: pencil, charcoal, and ink. While crayons, colored pencils, colored markers, and other drawing materials offer a world of splendid opportunities for the landscape artist, it's hard to beat the black-and-white simplicity of pencil, charcoal, and ink.

Pencil

By far, the sketching tool I use the most is the common, garden-variety, yellow No. 2 pencil. It's soft enough to leave a dark mark, yet firm enough to retain

Detail
The Hudson Highlands from Garrison
Pencil drawing, page 50.

its point for a reasonable length of time. Although it is intended for general writing purposes more than for drawing, I find it quite effective. It's also the least expensive of all art materials and always widely available; many companies manufacture No. 2 pencils, with slight variations among brands.

Softer pencils sold specifically for drawing (3B, 4B, 5B, and so on, up to the softest, 9B) leave a dark line and can fill in tonal areas rapidly. However, the softer the lead, the faster the point wears down with use. Whichever type you use, keep several sharpened pencils at hand when you draw.

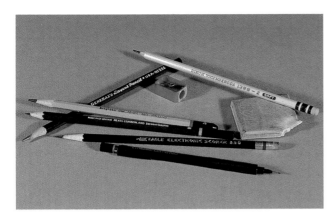

Assorted pencils. From top: Dixon's No. 2, General's layout pencil, Bruynzeel 4B, Derwent 4H, electronic scorer, and Pentel mechanical pencil. Also pictured: kneaded eraser and small hand-held sharpener.

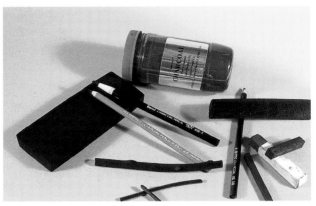

Charcoal products. Clockwise from left: Sennelier Baton de Saule, General's charcoal pencil, Berol charcoal pencil, General's charcoal powder, Sennelier Maxi Decor, compressed charcoal, Ritmo charcoal pencil, and vine charcoal.

Always pay attention to your pencil point. A different kind of line results from using a dull point rather than a sharp one. While variety of line is usually a worthwhile quality to seek in a drawing, create your variations on purpose, not by accident. If you want a crisp, clean mark, use a sharp pencil; for a soft, fuzzy mark, use a dull pencil.

Charcoal

Charcoal comes in four forms: stick charcoal, compressed charcoal, charcoal pencils, and powdered charcoal. All are suitable for landscapes, although we won't consider the fourth here, since it isn't practical for outdoor work.

Stick charcoal, as its name suggests, is made from sticks that have been charred. Wood is carefully heated in kilns until the organic material has been burned away, leaving only dry carbon. The thinnest variety, vine charcoal, is commonly made from willow. Frequently used in life drawing classes, it makes a delicate mark that can be softened by smudging, is easily brushed away, or can be deepened by repeat applications.

Compressed charcoal combines pulverized particles of charcoal with a binder, usually linseed oil, and the mixture is then squeezed into chalklike sticks. The deepest dark marks are possible with compressed charcoal, but they do not erase well.

Charcoal pencils are easy to use—just like a pencil. Since the rod of charcoal is sheathed in a paper or wood casing, only the point is exposed, so your hands remain clean. Charcoal pencils are often used in combination with white chalk.

Ink

For centuries, artists have used India ink with pens and with brushes. An excellent medium for landscape drawing, ink can be thinned with water to create tones, or used full strength for its capacity to make intense blacks. For my own outdoor work, however, I've come to enjoy ballpoints and sketching pens with nylon or felt tips.

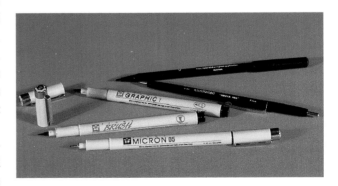

Pens. From top: Penstix, Illustrator, and three Pigma pens (Sakura)—the Graphic, Brush Pen, and Micron.

The ordinary ballpoint has long been one of my favorite drawing tools. But unfortunately, there are two problems that have plagued these pens since their inception: nonpermanent ink and "glopping." My best advice is to watch the point carefully for ink clotting, and wipe it off before it hits your drawing.

As for permanency, there is good news. A pen called the Illustrator, by Griffin, is designed specifically for illustrating and general sketching. Available in three line widths, it contains lightfast India ink and features a carbide ballpoint. The pen draws easily and smoothly, with minimal skipping or clotting.

Felt-tip markers and fiber-tip pens round out my list of basic sketching materials. The Pigma Micron by Sakura is a prefilled, technical-style pen with a nylon nib that is ideal for making freehand drawings with hatch marks, little squiggles, and assorted dots. Pigma pens contain odorless, waterproof ink that will not fade or discolor, dries quickly, and once dry, will not bleed or smear.

The Pigma Graphic marker is similar to the Micron, but with a larger nib of 1, 2, or 3 millimeters (all smaller than $\frac{1}{16}$ inch). The Pigma Brush Pen has a nylon brush nib that is firm, yet flexible. It can make a very narrow line or one as broad as an old-fashioned laundry marker. All three of the Pigma pens use the same pigment-based permanent ink, so you can use

them all in the same drawing without any noticeable variation in color.

Sketchbooks

Every artist should have a few sketchbooks. They are convenient to use and easy to store, and come in a wide variety of sizes, bindings, paper weights, and quality. Small books can be carried everywhere to record ideas, both written and drawn, for future reference.

For general purposes, I recommend a 9 x 12" medium-weight sketchbook with a medium-textured surface. A rough surface is good for charcoal, but isn't commonly used for pen-and-ink work. Conversely, a smooth surface is ideal for ink but won't hold charcoal very well. For charcoal, you may even want to try some of the pastel papers mentioned on page 29.

Erasers

While there are several types of erasers on the market, I use kneaded erasers the most. They are gentle on papers, and can be molded into many shapes for drawing effects. Remember, erasers are not merely tools for removing mistakes; they are equally useful for softening lines, modifying tone, and creating light marks within a dark mass.

Blenders

For charcoal or pencil drawing, you may want to employ some simple tools to blend tones and soften edges. Rags, tissues, old socks, even your fingers will do. For tight spots, I use a paper stump—a tightly wound roll of paper or felt, pointed at each end—or a tortillon, which has one pointed end and one flat end. Both of these inexpensive tools come in handy for altering the character of a drawing.

Sharpeners

I like to sharpen my drawing pencils with a knife. There is nothing like a hand-sharpened pencil point. But, for convenience, other sharpeners include electric, battery-operated, crank models, sandpaper blocks, even the tiny take-along sharpeners that tuck into a pocket (but a small knife works as well—and it can also slice an apple).

Sketchbooks. Clockwise from left: Utrecht, Derwent, a newsprint pad, T. H. Saunders, a hardbound, Strathmore Recycled, Rives Bristol, and Sennelier.

Pastel Materials

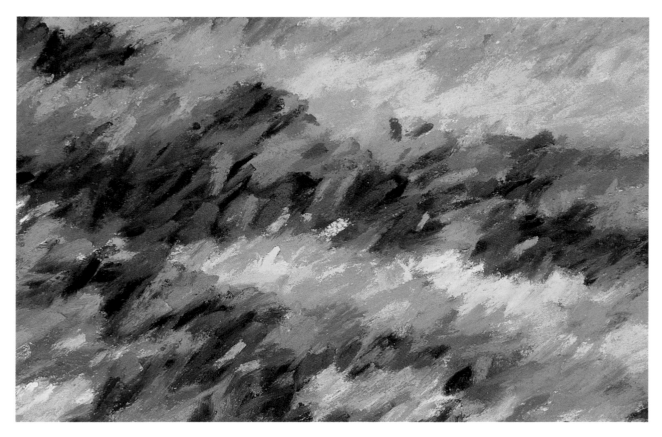

Pastel is a wonderful medium: direct, vibrant, and reasonably forgiving. Unlike working with oil, when working with pastel you needn't spend time mixing colors or waiting for paint to dry. However, you *must* have a wide assortment of pastels to choose from, since you need a separate stick for every color in the picture. It is important to have several values of each color, from light tints to dark shades.

Pastel is pure pigment mixed with a dry binder, gum tragacanth, then rolled or pressed into sticks. When applied to a surface with a receptive texture, such as rough paper, sanded paper, or abrasive board, the colored pigment becomes embedded in the tiny crevices, the "tooth" of the paper.

Soft Pastels

Try several types, for they all have a slightly different feel. I use a mixture of brands when I work, as do many pastel artists, but Sennelier is my favorite brand. These superb pastels are richly pigmented, soft and easy to apply, and come in the largest selection: 525 colors. I also use Rowney, Schmincke, and Unison when I want a lusciously rich and soft pastel. Other brands, such as Grumbacher, Rembrandt, and Holbein, are firmer in texture and less costly as well. They function nicely for building up an image.

Time and time again I've seen students struggle painfully with pastels when trying to paint landscapes. They may have pastel sets of 48 or 60 colors, but not necessarily enough of the right hues. Avoid that

Detail
WSA Grounds
Pastel, page 63.

problem by adding to your palette, especially some deep, dark shades.

If your local art store allows you to chose individual colors, you are in luck. Otherwise, the best thing to do is request a color chart from a mail order art supply company, and purchase single sticks from open stock.

Hard Pastels

Obviously firmer than soft pastels, hard pastels are what I use in the initial stages of a painting as I'm blocking in the image. Since they are dense in their makeup, less pigment is distributed on the paper with each stroke than with a softer pastel. As a result, the paper's tooth does not become filled up with pigment so quickly. This allows me to build up a few layers, then follow with soft pastels on top.

The most popular brand of hard pastel is NuPastel by Eberhard Faber, currently available in 96 colors. Sakura makes an excellent hard pastel as well, called Nouvel Carré, which comes in 150 colors, including 12 fluorescent hues. This brand is unique in that the sticks are water-soluble. You can brush water into your artwork for watercolor effects or you can even dip the sticks into water and "paint" with them.

Sharpening a hard pastel with a blade ...

... or on a rock.

Pastel Pencils

Pastel pencils offer essentially the same quality of color as hard pastels, but are shaped into a thin rod like a traditional wood-cased pencil. Since they can be sharpened to a fine point, they are handy for clarifying edges and for rendering grasses, thin branches, and such.

Pastel pencils are also useful for blending color in a pastel painting. Instead of softening a tone by smudging it, many artists tie colors together by superimposing a new layer of hatched strokes with a pastel pencil. This procedure blends color between two areas with vitality and fresh rhythm.

Popular brands are Carb-Othello, Conté, Derwent, and Bruynzeel. Of these, I prefer the last two, Derwent for its large selection of 90 colors, and Bruynzeel for its smooth consistency and water solubility.

Oil Pastels

Oil pastels are a combination of pigment, oil, and wax that has been molded into a crayon or pastel shape. They are available in a great range of opaque, permanent colors that possess a notable capacity for being "slurred" together to achieve painterly effects. Unlike soft pastel, oil pastels adhere to almost any surface—they don't need a paper with tooth. Oil pastels and soft pastels are not customarily mixed; except for experimental techniques, it is best to buy a set of each and use them separately.

Sakura has recently developed a set of artist-grade Cray-Pas with an assortment of 85 colors. For a higher concentration of pigment and a lipstick-soft consistency, try the Sennelier oil pastels, offered in 105 colors. They have a reputation among artists as being the best on the market. Sennelier also makes a line of "giant" oil pastels in an assortment of 69 colors. Equivalent in mass to 18 regular oil pastels, a giant oil pastel is perfect for covering large areas.

Pastel Papers and Supports

You owe it to yourself to use a good-quality, acid-free paper for your pastels. Since oil pastels will stick to most any surface, I will concentrate here on supports for soft pastels, which need a surface texture, or tooth, to hold the particles of pigment.

Of the mildly textured pastel papers on the market,

Papers and supports for pastel. From left: three Canson papers, Ersta sandpaper, Wallis sanded paper, three La Carte Pastel papers, and two Solid Ground pastel supports.

one of the most popular is Canson Mi-Teintes. Many pastelists find this paper indispensable for its wide selection of 51 lightfast colors. If you work with a loose, open stroke, the hue of the paper shows through, unifying the color of the finished design. This medium-weight paper has a neutral pH and comes in a number of sheet sizes as well as large rolls.

La Carte Pastel has a soft, slightly abrasive surface, similar to flocked wallpaper. The uniform tooth holds pastel so well that fixative is rarely necessary. Made in France and distributed by Sennelier, La Carte Pastel comes in a range of 14 colors.

Sanded pastel paper is an absolute delight to use. The fine grit of sandpaper is extremely receptive to the pastel, and it is possible to apply many layers without losing color intensity.

Wallis Pastel Paper was formulated to solve the problem of permanency. It provides an exquisite surface, quite similar to sandpaper, but its durability makes it completely archival. It also accepts underpainting nicely. I've used gouache and diluted oil paint on it, and they both work well.

Yet another surface, and a superb one indeed, is the abraded polymer pastel board called Solid Ground. It is completely archival, strong, lightweight, and impervious to the evils that plague many other supports, *and it's washable*. That's right—if your image is a disaster, just put the entire board under the faucet and scrub it

out with a sponge or toothbrush. It works like a charm. You can also sponge off small portions of the design while you work, without disturbing the rest of the image.

Fixatives and Accessories

When several layers of pastel have been applied to the paper, there can be a buildup of pastel particles that is too thick for subsequent layers to stick. When this occurs, some artists will use what is known as a workable fixative to "set" the first layers and allow more pastel to be added on top. The trouble is, fixatives usually darken the colors a bit. So if you use fixative, I suggest that you never apply it over your final pastel layer. I seldom apply any fixative to my pastels. Since I work primarily on surfaces with a considerable amount of tooth, layering is possible without fixatives, and framing with glass protects the pastel artwork.

Your hands can get mighty dirty when you're using pastel, so you should keep a cloth nearby. Handi-Wipes towelettes are tremendously convenient, too. One of the most useful pastel accessories I've found is a can of compressed air, available at most camera stores. It sends a precise blast of air through a thin nozzle to any area of your painting that needs correction. The force of the air easily removes unwanted strokes of pastel, restoring the original surface tooth of the paper.

Not all pastel artists like a soft, blended image. I prefer a direct, painterly surface myself, but there are

Fixatives and accessories. Clockwise from left: compressed air, Artwipes, spray fixative, single-edged razor blade, tortillon, and Silverbrush pastel blenders.

times when you will need to soften an edge or blend a shape. For such effects, a chamois, tortillon, or blending stump will work nicely, as will your fingers or the heel of your palm.

An unframed pastel painting is reasonably resistant to vertical pressure, but is extremely susceptible to smearing by lateral pressure. In other words, you can stack one on top of another without much damage, but a friendly visit from a tail-wagging dog can be disastrous. When traveling, I have often layered several pastel paintings together without harm. I tape the largest one, face up, to a rigid board and then tape down a layer of waxed paper. I place another pastel directly on top, laying it down carefully and taping it down as well. After layering several pastel paintings, each taped in place with a protective sheet of waxed paper, I put a rigid board on top and tape it all together like a sandwich. As long as nothing can slide around, which is the purpose of all the taping, the images are safe and will not smudge.

Tips for Protecting Pastel

Pastels need to be protected from smearing, and are best preserved when matted and framed under glass. Even then, you should be careful of two things: Do not place the painting in direct sunlight, for the sun's heat could create humidity under the glass, causing moisture to develop; and, whenever the pastel is not hanging on a wall or leaning vertically upright, always lay it face *up*, never face down.

My framer includes an extra layer of matboard underneath the primary mat, set back a half-inch (about one cm) from the window opening. This creates a trough that will catch stray pastel particles that may become dislodged if the painting needs to be shipped. He also closes up the back of the frame with little turn buttons instead of brads or glazing points. These make it easier for me to open up a frame to rework a pastel or to switch images around from frame to frame.

Illustrated here are the back of a frame with turn buttons, a beveled linen mat, and the back of a mat, showing matboard spacers.

Several pastel paintings taped together between layers of wax paper and taped into a portfolio for transport.

Oil Painting Materials

Detail
The Flooded Roadway (Church on a Hill)
Oil, page 129.

Artists have been painting in oil for about five hundred years. During the course of these centuries, a multitude of adjustments and improvements have been made in paints, brushes, supports, tools, and other materials, and refinements and innovations in the products oil painters use continue to hit the market at an astonishing rate.

Note that while this section covers materials used in oil painting—the only paint medium discussed in this book—it contains much information that could apply to acrylic or watercolor painting. Of course, that is provided you make the necessary adjustments specific to each medium.

Paints

We have five times the assortment of pure colors available today as did the old masters, and for the most part, the quality of today's paint is superior. Of the myriad brands of oil colors manufactured, some of the most popular labels are Gamblin, Grumbacher, Rowney, Sennelier, Rembrandt, and Winsor & Newton.

As artists become more concerned with the permanence and safety of their materials, an increasing number of paint makers are creating colors that conform to standards set by such organizations as the American Society of Testing and Materials (ASTM). When you choose colors, try to select those with a lightfastness rating of I (excellent) or II (very good).

Basic Colors
White is our most important oil color. Half or more of the paint in a typical oil painting is white, so it is

important to choose a good-quality white. The pigments in popular use are titanium, zinc, and lead (flake). Each has distinct traits, both good and bad, but there has yet to be a perfect all-around white. Some chemists and conservators suggest using a mixed white, giving us the best properties of each while minimizing their individual faults.

Titanium white is the most brilliant and the most opaque. It has strong tinting strength and a fairly neutral temperature. Titanium is versatile and is not prone to yellowing with age. Zinc white is cooler and less opaque than titanium. Zinc dries more slowly and is often used by landscape painters who work alla prima. A titanium-zinc mixture makes an excellent white, with the opacity of titanium and the creamy texture of zinc. Flake white is the standard designation for the highest-quality white lead. It is a heavily bodied warm white, ideal for impasto or painterly effects. However, it is toxic, and many artists avoid it. One company, Gamblin, now makes a nontoxic flake white replacement, with the same handling characteristics as the original.

Beyond white, there are hundreds of colors from which to choose, but you don't need very many. My average set of colors includes a good white plus two reds, two yellows, and two blues, along with a few earth colors and convenient secondaries; my fun colors are those odd hues that I like to try out from time to time. I usually reserve a spot on my palette for a "guest color," because it sparks me to try new mixtures. The colors described here are those that make up the average set I use for painting landscapes (though not all at once), plus a few additional ones I enjoy, and white.

Alizarin crimson is a cool, strong, dark, slow-drying transparent red. It is a versatile color in glazes and mixtures, and makes a particularly rich purple when mixed with ultramarine blue.

Cadmium red is a warm, bright, opaque red. It is lightfast, permanent, and ranges from an orange red to maroon. I prefer the cadmium red medium, which I find most versatile.

Cadmium yellow is brilliant and opaque. There are several designations, each similar in value but with a range in hue from a pale lemon yellow to a cadmium yellow deep, the color of a school bus. The latter is the warmest yellow, and makes a great orange when mixed with cadmium red.

Yellow ochre is a subtle, handy yellow, though it can seem "chalky" in green mixtures. Raw sienna and Mars yellow function a bit like darker versions of yellow ochre, and can create more interesting greens. Naples yellow is lighter, and a useful color in mixtures for lightening and warming another color.

Ultramarine blue is dark, semitransparent, and extremely useful in mixes as well as glazes. It makes a great "dark" when combined with alizarin, and a good neutral when mixed with umber or burnt sienna. Lightened with white, ultramarine is particularly useful for adding depth to a landscape, and creating atmospheric touches.

Cerulean blue is a lighter blue, with its name derived from the Latin caeruleum, meaning sky blue. An opaque color, it makes a variety of believable greens and grays. Manganese blue is comparable in hue but is transparent.

Notice that I mention *no green*. I believe that more landscapes are ruined by tube green than by anything else, and I do not encourage its use in class.

Matching the color of a leaf with green paint from a tube does little to convey the foliage as it exists in nature. The moment a blob of tube green is squeezed out onto the palette, the novice painter falls victim to symbolic thinking: "See a tree, paint it green. See a rock, paint it gray." He then fails to see the subtleties of light and atmosphere in the landscape. Mixing greens from scratch, however, will make painters look more closely, thereby improving their skills.

Additional Colors

There are several blue hues that I enjoy using from time to time. One of them is **cobalt blue**, a middle-value blue that is bright and clear; it is similar to ultramarine (though never so deep) but leans more toward green. **Phthalo blue** is a modern equivalent to Prussian blue, with the same working properties, including excellent lightfastness, great tinctorial power, and a coppery sheen. It has such tinting strength that it can

easily dominate mixtures. Just a little bit on your brush can get into everything. You must be miserly with its use. However, a small dab of phthalo blue can do wonders for rejuvenating a tired mixture that just doesn't seem *blue* enough. Another blue that is one of my favorite of all colors is **indigo.** It is a very deep, transparent blue, almost black when in concentrated form, but it produces a variety of excellent tints and glazes.

A good warm color is **burnt sienna**, an earthy red-brown pigment that is semitransparent, a great mixer, and a fast drier.

Orange and **violet** are secondary colors, like green, and they could easily be excluded from the palette, but I use them for a few select purposes. I rarely need the intensity of cadmium orange, finding a mixture of cadmium red and cadmium yellow to be bright enough, but I use some of the transparent oranges for glazing, like Gamblin's transparent earth orange or Sennelier's Chinese orange. Other fun colors are alizarin orange golden (Williamsburg) and Italian pink (Rowney). When I include violet on my palette, it's primarily to keep color intensity in dark passages and to use in glazes.

The use of **black** is often discouraged because it's difficult for a beginner to control. Fine for small touches, it can be boring if used to darken a mixture. I prefer to paint dark passages with the liveliness of colors such as indigo, alizarin crimson, or violet. When mixed with yellow, though, black makes a very good green.

Through trial and error, you will learn and remember what colors work well together. Stay open to new ideas about color, maintaining a balance between the proven and the unorthodox. Flesh, for example, once a popular color in amateur paint sets, is a horrible color for portraits, but can be tremendous in landscapes.

Solvents, Mediums, and Varnishes
Sometimes you will want to dilute or modify the working characteristics of oil paint. Solvents function as thinners and dissolvers. Mediums, a term that takes in an abundance of substances, are also at your disposal to thin or thicken paint, accelerate or retard drying, and increase or decrease gloss. Varnishes are used

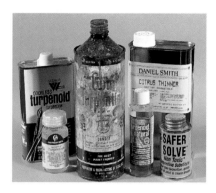

Solvents. From left: Turpenoid, turpentine (small and large containers), Turpenoid Natural, Citrus Thinner, and Safer Solve (turpentine substitute).

for retouching and to give a final protective coat to finished oil paintings.

Solvents
The solvent most commonly used by oil painters is distilled turpentine; 100 percent pure spirits of gum turpentine is best. Clip your palette cups to the edge of your palette and fill one about halfway with turpentine. Dip your brush into the cup if you want to make your paint more fluid, and also when you need to clean the brush of color.

Although turpentine is the standard, many people have trouble with its fumes. Of the turpentine substitutes on the market, I prefer the citrus peel solvent made by Daniel Smith. It works well for thinning paints and cleaning brushes, and has a pleasant orange smell. The American Color Company manufactures a similar product, Safer Solve, that is nontoxic and nonflammable, making it the solution, so to speak, for air travel, since volatile turpentine isn't allowed on planes. American Color recently introduced another turpentine substitute (made of odorless mineral spirits) with the great name Turpenstein.

Painting Mediums
There is universal disagreement as to which medium is best. It is a choice you must make for yourself. Of the many recipes for painting mediums, one of the most favored combinations for all-purpose painting consists of $\frac{1}{3}$ damar varnish, $\frac{1}{3}$ linseed oil (or stand oil), and $\frac{1}{3}$ turpentine. Damar varnish by itself makes the paint film too brittle, and if oil is used alone, it takes too long for paintings to dry. The "$\frac{1}{3}$ to $\frac{1}{3}$ to $\frac{1}{3}$" recipe seems to strike a workable balance.

Alkyd resins decrease the drying time of the paint and work very well for glazing. Liquin, by Winsor & Newton, is perhaps the most widely known, but excellent alkyd resins are also made by Gamblin, Daniel Smith, and others.

With all painting mediums, remember to use your thinnest paint in the bottom layers of the painting, and increase the amount of medium in the top layers. It's best to choose one type of medium and use it throughout the painting. A natural resin such as damar varnish must be thinned with turpentine, while an alkyd resin like Liquin may be diluted with mineral spirits, a milder solvent.

Varnishes

In addition to varnish discussed above, under mediums, there are two other types of varnish to consider: retouch varnish and final varnish. Retouch varnish is a very thin solution that is applied as a temporary coating on paintings. It will restore gloss to any colors that have "sunken in" and become dull when the painting is dry to the touch. This allows work to continue on the canvas with a uniform surface sheen. Retouch varnish is also used as a temporary varnish to protect work for the first six months or so, before a final varnish is applied.

After at least six months (some say a year), the paint is sufficiently dry so that a coat of final varnish may be applied. The purpose of this final coat is to protect the painting from dirt and pollution. Any dust that settles on the painting's surface can be easily removed from the varnish layer. Damar is often used as a final varnish, although it has a tendency to become brittle and yellow with age. Final varnish should be reversible so that if it becomes soiled, it can be cleaned off and replaced with a fresh coat.

When varnishing, be sure to select a dry day, and work in a dust-free room. If the day is humid, moisture particles will be trapped in the varnish layer, causing a cloudiness known as "bloom."

Another alternative is a wax varnish, made with beeswax and mineral spirits. It is easily applied and buffed with a lint-free cloth, much like waxing furniture. The degree of gloss is dependent upon the amount of polishing—as simple as that.

Mediums and varnish. From left: squeeze bottle for Liquin (once held household cleaner), Liquin, wax varnish, spray matte varnish, tube Oleopasto, gloss varnish, stand oil, damar varnish (can), retouch varnish, damar varnish (jar).

Oil Painting Supports

"Support" is the term given to any material or substance that serves as a surface to hold the paint. It's the thing you paint on. Almost anything will work to some degree, but here I will discuss only the most widely used surfaces. Supports fall into two categories: flexible (canvas and paper) and rigid (wood, fiberboard, plastic, and metal).

Flexible Supports

Canvas has been used by oil painters since the fifteenth century, and is as popular today as ever. Both cotton and linen canvas are suitable materials; they are lightweight yet strong enough to provide a good surface for the paint. Linen fibers are much longer than canvas fibers; hence, linen is stronger, and it also has a more interesting weave. Cotton canvas is less expensive, though, and is less likely to sag under adverse atmospheric conditions. Select a heavy enough grade, prepare it properly, and it should work just fine.

To create a flat surface for painting, canvas is stretched over a wooden framework, or chassis. If the framework has expandable corners, it is called a stretcher; if the corners are fixed, the framework is called a strainer. The canvas is tautly stretched over the chassis and held in place with tacks or staples. Next, the surface is sized with glue to isolate the canvas from the layers of paint. Many museum conservators recommend polyvinyl glue (like Elmer's), diluted with water.

Once a canvas has been stretched and sized, it is ready for the first layer of oil priming, made from white pigments, oil, and solvent. It is left to dry for about a week, lightly sanded, then coated with a second layer of priming. You can use acrylic gesso to prime a canvas, in which case, you can eliminate the sizing step.

Many artists enjoy painting on paper, and if properly primed, it is completely acceptable. Be sure to use good acid-free paper, though. Both heavy watercolor and printmaking paper are fine. Daniel Smith sells a "non-buckling board" that is an epoxy-impregnated paper impervious to the rotting action of oil colors. You can paint directly on this surface without having to size or prime it.

Rigid Supports

Rigid supports, traditionally of wood, were in common use long before canvas. The wood is generally coated with a gesso ground that is receptive to oil paint. Larger panels must be braced to prevent warping. Cigar box lids become supports for studies—a usage that was very popular with American Impressionists and the early Woodstock painters.

Untempered Masonite panels make an excellent surface. Cut the Masonite to size, sand lightly, and coat with a few layers of acrylic gesso, sanding between coats.

By far my favorite rigid support is one called Solid Ground, made of archival-quality polyvinyl plastic resins and fine pigments. Solid Ground is a ½- or ¼-inch-thick panel of an acid-free plastic material that is lighter and stronger than Masonite yet provides an excellent surface for oils or other media. I find the texture of the panels just right for my needs; it is neither too smooth nor too rough, neither too absorbent nor too slick, and you can paint right on this surface without gesso or oil primer.

Brushes

Get the best you can afford. They may all look alike in a store or in a catalogue, but the bristles of the poor ones lose their shape quickly. A brush is the natural extension of your hand, and therefore of you. You don't want the instrument that conveys the subtle nuances of your artistic personality to be of inferior quality.

Good brushes can be costly, but poor brushes are a severe handicap to good painting. Start with a few good brushes, treat them well, and add to your supply gradually. If you choose your brushes wisely, they will provide you with superior service for a lifetime. My favorite brands of brushes are Isabey, Winsor & Newton, Grumbacher, Robert Simmons, and Silver Brush.

The standard brushes for oil painting have tips made of bleached white hog's bristles or red sable hair.

Flexible supports. Clockwise from left: brick molding to make your own stretchers, raw linen, commercial stretcher strips (with keys), canvas on a roll, and a stretched linen canvas (preprimed), with staples affixed outward from the center toward the corners.

Rigid supports. Clockwise from left: a wood cigar box typical of those dismantled to use as painting panels, a wood panel made by the John Annesley Company, Solid Ground painting support, and underneath them all, a piece of untempered Masonite.

Bristle brushes are used for most of the painting process, with the sable primarily reserved for refining and finishing techniques. There are also oil painting brushes made with synthetic filaments, and natural-synthetic blends have been created as well, combining the availability, durability, and low price of the synthetics with the softness and absorbency of natural hairs.

Different brushes will produce different effects in your paintings, so try a variety. Furthermore, the inherent character of a brush will change over time as it wears. It may be necessary to trim off a few stray hairs every once in a while, but don't change the shape of a brush by cutting its ends.

Regardless of the type of hair or bristle, the manufacturing process is about the same for all brushes. A seamless metal tube called a ferrule is the connecting unit between the handle and the brush head. Traditionally, two lengths of brush handles have been manufactured for artists. For easel work, long-handled brushes are preferred so the artist can hold the brush head at arm's length, often using large, gestural movements. In situations that call for holding the brush close to the tip, short-handled brushes are usually the choice.

Bristle Brushes

The tip of hog bristle has a natural split end, called a flag, which is important to oil painters in that the flag tip holds and deposits a lot of paint in a smooth and continuous stroke. Bristle is durable, resilient, and manipulates heavy paint easily. A good brush gives a completely controlled stroke, with sensitivity and durability, and will retain its shape for years of painting.

Bristle brushes are available in four basic shapes: round, flat, bright, and filbert. Most of these shapes are made in sizes from no. 0 (small), to no. 12 (large), to no. 24 (extra large).

Rounds hold a lot of paint and are good for drawing lines or making scribbles and dots. Bristle rounds are somewhat blunted and don't necessarily come to a sharp point like watercolor brushes. They were at one time the most commonly used type of brush, but are not as versatile as flats.

Flats are set in a ferrule that maintains their rectangular shape. They are capable of making broad, sweeping strokes, and can carry a full load of paint. Turned on their thin axis, they make thinner lines—much like rounds. Flats are probably the most frequently used brushes for landscape painting.

Brights are shaped like flats, but the bristles are shorter and the brush is much stiffer. Brights do not hold much paint, and are used for scrubbing effects on the canvas or for applying very buttery paint.

Filberts look like flats that have been slightly used. Their outer edges curve inward, forming a brush shape that is almost a cross between a round and a flat. Filberts are available in various lengths of bristles, with an extra-long, more supple version that is sometimes called an Egbert. Filberts are my favorite shape because they are so versatile. Since filberts don't have such sharply squared-off bristles as flats and brights, they produce marks with a softer edge, yet they are certainly firm enough to apply paint aggressively.

Sable Brushes

Sable brushes for oil painting are made of much softer hair. Artists use red sable brushes (made from the tails of the red tartar marten) for paint strokes of a smoother, more precise nature. Sable is also useful for delicate blending or when you are working with thinned oils.

Sable rounds are more pointed than bristle rounds and perform especially well for painting details and fine lines. A round sable brush can indicate thin branches or grasses with just an experienced flick of the wrist.

Sable flats are soft, squared-off brushes that create a wide stroke of color without leaving ridges of paint. They are also used for blending and for glazing.

A Basic Selection

Your basic landscape outfit should include two each of bristle flats or filberts in sizes 2, 5, and 8, plus one or two larger brushes. For sable brushes, you will want at least one or two small rounds, and possibly a flat. You must learn which ones work best for you.

Landscape is concerned with far more than recording an inventory of pastoral objects. Good landscape drawing and painting is usually about the many three-dimensional forms of nature as they appear in three-dimensional space. That is, a landscape artist is most likely interested in forms *as they are influenced by light.* And to show forms in light, tonal drawing is highly effective.

Charcoal is ideally suited for creating tonal images. It can produce a wide variety of tones and can be manipulated quickly and easily once it's on the paper. Although ink from a pen creates very dark lines, they can be effectively grouped in a number of ways to give the impression of various gray tones, as in *The Dieselhorst Bridge.* Cross-hatching and stippling are the two most common methods of achieving halftones in ink. Of course, with a brush and a bit of water, ink can be diluted to any number of intermediate shades of gray.

Pencils, the most popular of all drawing tools, have the capacity for rendering soft, smudged tones with no visible pencil strokes, just as with charcoal or an ink wash, yet they can easily give forth an array of crisp, sharp lines, rivaling the clarity of ink.

Keeping a Sketchbook

A sketchbook is the most important possession an artist can own. Using it is the most important activity. Keep a sketchbook as long as you live. A good size is 9 x 12", although smaller sketchbooks are also useful and easier to carry. With a few pens or pencils and an eraser, you're all set.

Below are sketchbook studies of various pencil and ink marks for creating texture and tonal mass. Exercises such as these should be ongoing entries in your sketchbook (a very productive way to use time in transit on a plane or train).

Landscape artists are constantly tromping out into the woods with a sketchbook under their arms. When they return, the pages may be filled with images of rocks and trees, quick studies of clouds, notations about color, compositional diagrams, or merely a collection of random ideas or poetry inspired by the walk.

Studies of detail should be carefully drawn, with their express purpose being the transcription of specific facts. Later, you can pick and choose how much of this information to use. Some artists rely on a camera for details and a sketchbook to capture their general artistic impressions.

Sketching the Landscape

Stand or sit in front of your motif and open your sketchbook. As you look at the landscape think in terms of the overall shape. Will this scene be best portrayed as a vertical composition? Horizontal? Square? If you're not sure yet, that's what the sketchbook is for: to find out.

Begin with what we call the "thumbnail sketch." Draw a few small rectangles on the paper, perhaps 3 or 4 inches square. It's best to keep these studies small so as not to get bogged down in details. The intent with a thumbnail sketch is to record the major shapes and values, without detail, and especially how they fit to-

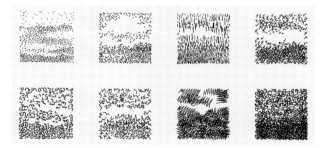

Develop a wide range of pencil marks to create tonal mass and texture. These eight squares show a small sampling of dots, dashes, lines, and squiggles. I'm sure you can create many more, and will find them to be very useful.

These eight squares show a fraction of the many pen strokes that can be combined to create a textural tone. By using a variety of pen nib sizes, you can significantly expand your repertoire of marks.

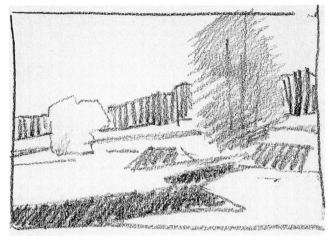

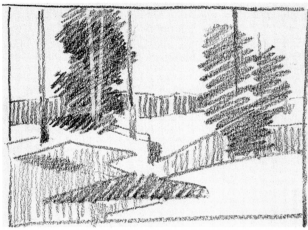

gether in the design. This is where composing begins. For this reason, we draw inside a little rectangle, known as a format.

It's extremely helpful to draw within a format. It defines the boundaries of the composition and therefore helps in aesthetic decision-making. Locating a shape in relation to these boundaries is just as important as rendering the shape itself. When you compose within a format, it's much easier to see the negative shapes that surround the objects in the landscape, and to arrange them all harmoniously. Also, on a practical side, in the margin outside the format, you have space to try various marks and scribbles.

Make a rapid sketch first. It has a greater chance of catching the transient spirit of the moment, even if lacking in particulars. Draw the essential thrust of the scene, and block in the values. In another box, draw it again, but try emphasizing different elements of the scene, or changing the values. If you are looking at a meadow with a light-colored barn next to a dark tree in front of a middle-value hedge, try reversing the values. If the scene seems horizontal, see if it can be forced into a vertical format.

Each of my first two compositional sketches above has elements I like, but I still need to explore the motif further.

I stretch the width of the format and combine my two impressions, exploring ways I might translate the drawing into paint. Ultimately, I decide on a shape somewhere between the second and third sketches. See the painting on page 166.

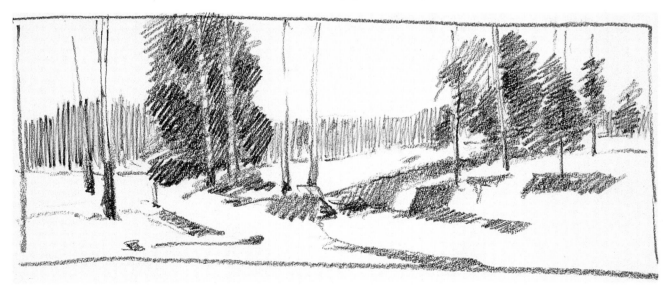

It is vital that you develop the skill of thinking out your designs and working with them to make them strong. More paintings are ruined in the first half hour by impatient students who "just can't wait to get painting." If they don't take the time to organize their thoughts, all the pushing around of paint will be aimless.

Landscape Drawing

Unlike landscape sketching, which is a preliminary procedure, landscape drawing can be a finished art form. Artists' private and preliminary drawings are prized by collectors, for such work reveals the thinking process of their creator. As with paintings, drawings intended for exhibition are frequently based on preliminary sketches and most likely have been scrutinized and compositionally refined—the only difference being the tools employed. Instead of paint on canvas, the artist has chosen to work with graphite on 100-percent rag paper.

My first landscape drawings began as sketches for possible paintings. Drawn in an inexpensive sketchbook, when completed, they remained in the book, eventually to be joined by other nature drawings until the book was filled, stored on a shelf, and superseded by a new sketchbook. From time to time I would glance through theses sketches, incorporating some of them into paintings.

By drawing, my drawing skills improved, and two things began to occur simultaneously. First, I came to really enjoy both the process and the results of landscape drawing. Also, I became increasingly disappointed when my drawings were unduly smudged. This led me to consider more permanent materials and storage techniques, and as an outgrowth of this transition, I began to make larger and more complex drawings. This in turn affected my small sketches in the field. In addition to hastily scribbled design notes, I developed the patience for making sustained drawings on location .

So, when you think of landscape drawing, think of diversity. Give thought to the *rapid sketch,* with its immediate capturing of shapes on the paper, with its value to the painter in retaining the germ of an idea for future embellishment in color. Consider the next step, the *compositional sketch,* wherein ideas of arrangement can be quickly explored, expanded, or discarded. Reflect too on the *study,* and how it offers each artist information on specific details. More important, it helps the artist to explore nature in depth and become intimately involved with the natural world by the very process of looking with purpose. And finally, think of the *exhibition drawing,* in which the artist concentrates as much serious attention as in a painting, but confines himself to the tools of drawing.

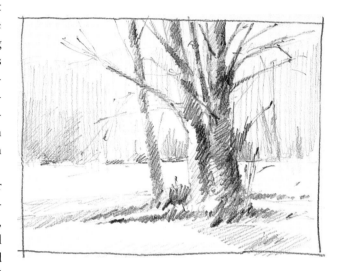

A compositional sketch like this helps you become familiar with your subject and aids in design planning.

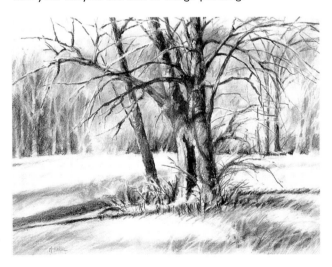

Dead Apple Tree
Charcoal, 9 x 11" (23 x 28 cm), 1988.

This tree was right outside my studio.

The Hudson Highlands from Garrison
Pencil on museum board, 38 x 30"
(97 x 76 cm), 1996.
Collection of Mr. and Mrs. Robert
Gravinese.

The Hudson River near West Point Military Academy was a critical point of defense during the American Revolution, which gave the locale added fascination for me as a painting site. But to tell the truth, I had just as much artistic interest in the foreground grasses and sky as I did in the history behind this famous view.

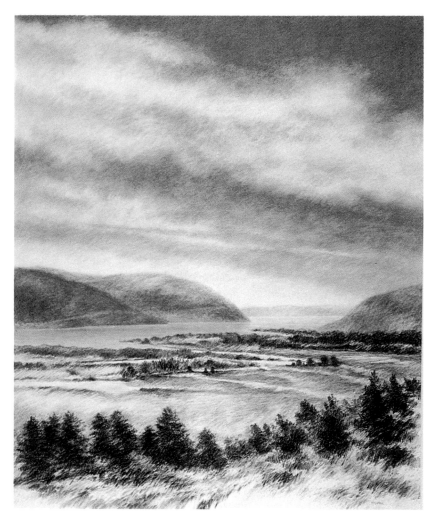

Hickory Study
Pencil, 10 x 8" (26 x 21 cm), 1993. Collection of Fairfield University, Fairfield, Connecticut.

Rather than a complete vista, this drawing is a detailed investigation of a small part of nature. It concentrates on the characteristic bark of a tree and is not concerned with the land, the rest of the forest, or a streambed at the foot of the tree.

General Approach

Make your first sketch simple, with basic shapes and values. In your second sketch, rework the composition and try new arrangements. For the third sketch, you can add details to support new design ideas. Now make adjustments based on how those details work within the design.

For tonal drawing, use a soft pencil or charcoal. Think of shapes and masses and not outlines. Try drawing with the side of the charcoal and make big marks. Another quick and easy sketching method for tonal drawing involves blocking in the rough design with charcoal. Then, with a brush and plain water, wash in to smooth out and soften the charcoal shapes. Now come back in with opaque white watercolor for highlights. Finally, return with charcoal to sharpen edges and create dark accents. Since water is involved with this procedure, it's important to use strong paper; watercolor paper is ideal.

The step-by-step demonstrations that follow are not meant to show the only way to proceed. Rather, they are close-up looks at how these particular drawings evolved.

Demonstration:

Pencil Drawing

I was asked recently to create a cover drawing for the Woodstock School of Art catalogue. Thinking this would be a good vehicle for demonstrating to you my basic pencil procedure, I chose a view of Studio 3, a classroom I've used often, in a setting that is quite familiar to me.

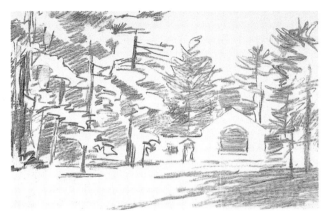

Step 1. This is a quick charcoal sketch done on the spot as a way to plan out the composition and establish my value scheme.

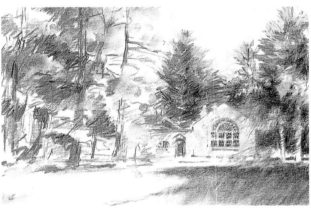

Step 2. The intent here was primarily to develop the large, distinctive window.

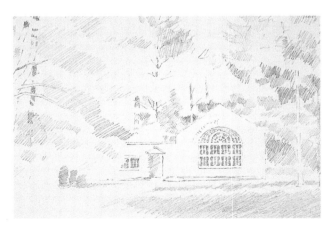

Step 3. Using an ordinary yellow No. 2 pencil, I start with a fairly light layer of parallel hatch marks to indicate the dark masses of foliage. I draw the general outline of the building and establish the character of the window.

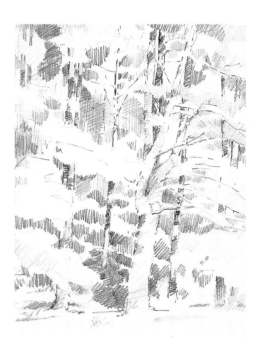

Step 4. The initial stages of the trees to the left result from a loose and gradual buildup of hatch marks and faint lines, a "mapping out" of the design.

Step 5. Now I start defining dark spots by pressing harder on the pencil. At this point, you can see a variety of light and dark marks that result from varying pressure.

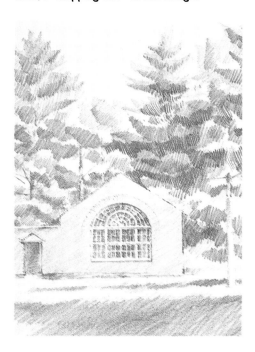

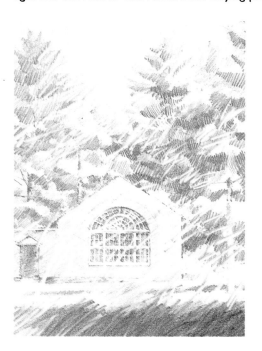

Step 6. Working on the building, I concentrate on the window. It is a complex shape and I don't want it to clash with the relaxed and natural quality of the trees, yet I do want the architecture to be drawn in correct proportion.

Step 7. I find that partial erasing helps to keep a passage from looking too stiff. Here, the eraser also drags light streaks through the dark foreground while pulling some graphite into the light areas.

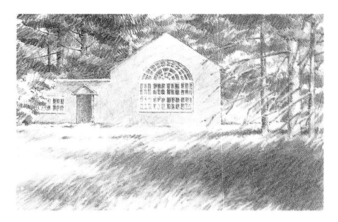

Step 8. Reestablishing the window and darkening selected portions of the design makes the building stand out from the background.

Step 9. Back to the trees on the left—another deepening of the dark masses and the addition of some branches add clarity.

Woodstock School of Art
Rt. 212, PO Box 338
Woodstock, NY 12498
(914) 679-2388

Non-Profit Org.
U.S. POSTAGE
PAID
PERMIT NO. 33
Woodstock, N.Y.

WOODSTOCK
SCHOOL OF ART
1997

Step 10. The finished drawing (for the catalogue's back cover) is the result of a relaxed process of building up values gradually through cross-hatching lines on top of the previous layer; using an eraser as a drawing tool; and always thinking in terms of tone rather than line as I continue to build up mass.

Studio Three
Pencil, 9 x 14" (23 x 36 cm), 1996.

This is the front cover layout for the catalogue with the lettering in place, corresponding to the foreground areas of light and shadow reserved for that purpose.

Demonstration:

Charcoal Drawing

Charcoal is easy to apply, smudge, erase, manipulate, and redraw. A paper with some texture is best, providing enough tooth to hold the charcoal particles. When the drawing is finished, apply a spray fixative to protect it from accidental smearing.

Step 1. This drawing begins with a hasty charcoal block-in based on one of my on-site drawings. With vine charcoal, I just map out the contour of the rocks and hint at the value placement. What attracted me in the first place was the diagonal movement of sunlit rocks anchored by the stable horizontal of the sea.

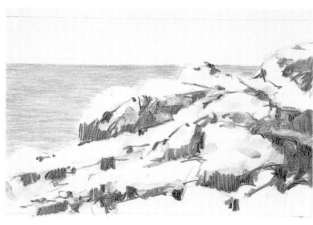

Step 2. I create a middle tone for the water by smudging the charcoal with my fingers. The spot where the rock breaks the horizon is important, but I'll balance its degree of emphasis with a large dark area in the lower right.

Step 3. The contour of the sunlit rocks is not defined by a line, but by a change of tone as the blank white of the paper stands out in contrast to the mid-tone of the sea. Dark portions of the rocks are built up in layers of loose hatching and smudging. The darks are not a solid black; there is a tonal range, though nothing becomes *too* light within the mass, for it's important to maintain the integrity of the dark shape.

Step 4. Here you can see a variety of values, hatching, finger smudges, and edges. I use a kneaded eraser to lighten areas and in some spots to lift out the charcoal completely. To achieve a straight line, such as where water and sky meet, lay a thin piece of paper over the sea area with its edge at the horizon. Begin your erasure strokes *on* the blank paper and pull them into the sky for a nice crisp line.

Monhegan
Charcoal, 9 x 13³/4" (23 x 35 cm), 1996.

The solidity of the rocks and the brightness of the day are accentuated by the wide contrast in value. A hint of grasses at the bottom provides textural variety without attracting too much attention, and also helps to "ground" the rocks.

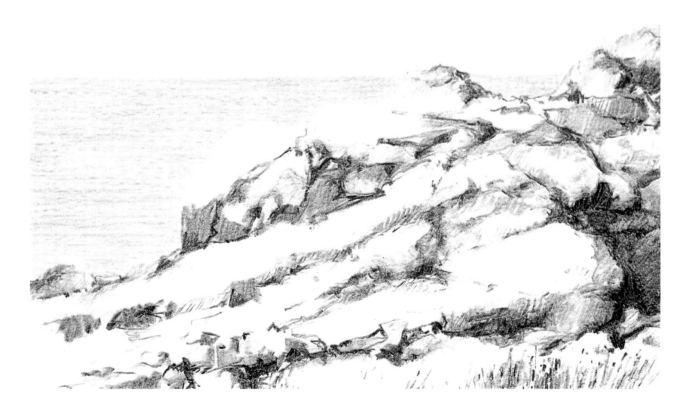

Pastel Techniques

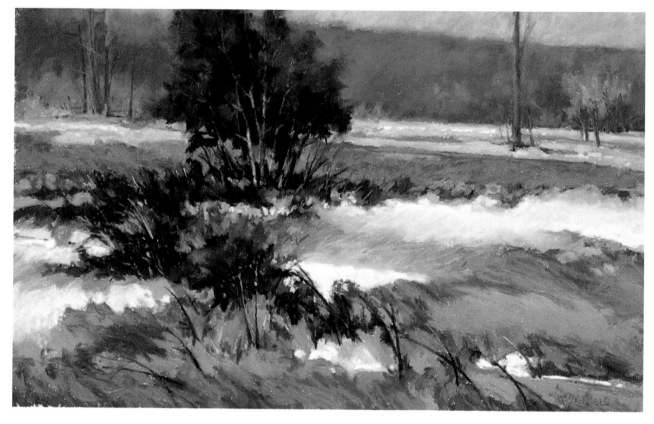

Little Red Berries
Pastel, 8 x 12" (21 x31 cm), 1993. Collection of Alan and Marilyn Kress.

Not all landscapes are direct transcriptions of nature. This pastel is a composite of images I remembered seeing during a January drive in the Catskill Mountains.

The pastel medium is wonderful in that it functions as a bridge between drawing and painting. Its immediacy and dry application makes one think of drawing, yet its vibrant colors relate pastels to painting. In fact, pastels can be either: When used to cover the entire surface of a paper or board, the artwork is considered a pastel *painting;* when a significant amount of the background support shows through and is an integral part of the design, the result is called a pastel *drawing.*

Perhaps the most important messages I could im-

part to anyone just beginning to use pastels are: A) Make sure you have an ample supply of pastels; don't handicap yourself from the very beginning with nothing but a dozen schoolyard colors. B) Work on paper or board with a receptive surface; slick sketchbook paper just won't do. C) Once you have your materials, practice some strokes before painting an image.

You must get acquainted with your pastels. Practice all the strokes listed and described below, and try combining them. Lay down some colors next to each other and blend them together with your fingers. Overblend them until they are smooth, but lifeless. Now you know one of the limits. Recognize overblending and avoid it in the future.

Practice a bit on smooth notebook paper at first, learn its limitations, then try pastel paper with more tooth, and then try sanded pastel paper. There is an enormous difference among the three.

Application Methods

There are a number of ways to apply pastel, each producing its own look. The surface upon which the pastel is applied can also create a distinct impression. Whether that surface is smooth, rough, or toned will have a profound influence on the way each stroke of pastel appears.

I believe it is important to keep the pastel strokes intact. The intensity of the pigment is part of its character, and this color purity is diminished by too much rubbing, blending, and fussing about. Confidently applied strokes reveal all the richness of the pigment, whereas uncontrolled blending is a prime cause of dull, exhausted paintings with no spark.

At left, this detail of the painting below points up how the color of the background trees at right was formed by a layer of fairly bright cool red, then modified with hatched lines from a blue Derwent pastel pencil.

Wild Irishman Bend
Pastel, 10 x 14" (26 x 36 cm), 1995. Collection Lisa and Christopher Chigas.

This is a scene along the Sacramento River that I just couldn't resist painting. I exaggerated the redness of the background trees to compensate for the intense mustard-yellow flowers in the foreground. Note how the water is not a generic blue but a reflection of the rosy sky, which is a very pale echo of those cool red trees.

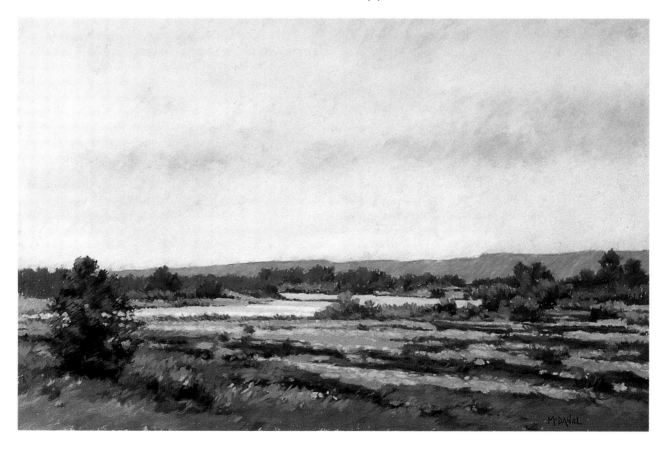

Here are descriptions of the various ways to apply pastel.

Linear Strokes

This is when pastel seems most like drawing. By using the tip of a razor-sharpened hard pastel stick or pastel pencil, you can create thin lines, and somewhat thicker lines with soft pastels. I like to use the long edge of hard pastels for sharp linear strokes, which are appropriate for creating the initial layout of a pastel painting. You can establish the general placement of the shapes and lightly indicate a value scheme without filling up the paper's surface with too much pigment. Although pastel pencils make fine lines and are clean to use, don't get in the habit of using them too often for an underpainting. Their use encourages an overemphasis on details at too early a stage. But pencils are great later on for firming up edges and drawing small details.

Hatching and Cross-hatching

Parallel strokes, known as hatch marks, enable an artist to create the impression of a solid tone while using a series of linear strokes. Layering a series of crisscrossed lines on one another is called cross-hatching, and describes a form with a "woven" effect that can be loose or precise, depending on the spacing of the lines. Color vibration results from juxtaposing strokes of different colors.

Cross-hatching, especially when used in combination with other techniques, adds great variety and is a useful method for manipulating an image, slowly weaving colors together to build up a form, or modifying the form after it is rendered. Cylindrical masses like tree trunks, rocks, or the human figure seem to be naturally suited to cross-hatching.

The best results for crisp hatching are usually achieved with a hard pastel or a pastel pencil. Soft pastels work—they just make a thicker and softer line. Combining hard and soft is often a good choice, for you don't want cross-hatching to look too mechanical. I like my hatch marks to come and go, to barely show up at times, perhaps as certain surfaces turn toward the light. Nor do all the strokes need to be absolutely parallel. An "organic" kind of hatching, with lines

going every which way, is very popular with landscape pastelists. You needn't be overly stiff and predictable.

Side Strokes

Hold the pastel stick with its side against the painting surface. As you move the pastel across the tooth of the paper, a wide path of color is deposited in a single stroke. If held lightly, the pigment reveals the texture of the support, resulting in a delicate, broken-color effect. A heavier touch fills in the surface of the tooth and makes a heavier, denser tone. Practice. Vary the pressure. Break your pastels into shorter lengths so you can create marks of a different width.

Blending

If done judiciously, blending is a good way to model form, soften edges, and create subtle gradations of color. Blending is also useful for describing the hazy, soft light of a sky. Make sure there is plenty of pigment on the paper, then gently rub one color into another with a chamois or soft cloth. For blending smaller areas, use a paper stump, a brush, or your fingers. As long as they are dry and free of grease, fingers make absolutely superb blending tools.

Slurring

Slurring is a type of casual, or incomplete, blending. You can push a few colors together by dragging a pastel stick through a shape, pulling some of the pigment along, while at the same time depositing fresh color from the stick in your hand. Work on an area that is covered with ample pigment, and it's easy to blend colors and add rhythm at the same time. It looks fresher than a thoroughly blended passage, and you don't wear your fingerprints off if you're working on sandpaper. NuPastels are ideal for slurring because they are a hard pastel with the firmness and smoothness to push around the existing pastel, yet they are strongly pigmented, and will add plenty of their own color.

An effective method of slurring can be achieved by overlapping the edge of a dark shape with a slightly lighter color. The edge of the second color can now be overlapped with yet another color, slightly lighter still. This creates a loose and vibrant modulation from shape to shape and from value to value.

Here the evidence of slurring is plainly visible. Separate pastel colors are partially blended together right on the paper. They are not softened with fingers or a blender; their mixture is simply the result of rubbing a pastel stick into a different color that has already been applied.

Feathering

With feathering, the idea is to drag a thin layer of parallel lines over the top of a previously painted section, allowing some of the underlayer to show through. By feathering over two adjacent shapes, you can unify them with the top layer, increasing color harmony. The effect is reminiscent of a glaze in oil painting or a wash in watercolor. Use a hard pastel or pastel pencil because a soft pastel will cover too well, unless you have a very light touch.

Areas in a painting can either be intensified (by feathering with bright colors) or toned down (using duller or darker colors for the feathering layer). Also try glazing over with a pastel pencil to modify the warmth of a form, or introduce the complementary hue to neutralize the color. Hatched in over a muddy or lifeless passage, top strokes can reanimate the weak section.

Scumbling

This is like a solid version of feathering. Drag one color over another, allowing some of the underlayer to show through. Hold a soft pastel on its side and skim it across the paper in a broad side stroke. If the paper has a pronounced toothy surface, the scumbled layer will catch the elevated ridges while the bottom layer will still be visible where it clings, like fog, to the lower valleys. Try scumbling in a sky to make vaporous cloud forms, mare's-tail clouds, and mackerel skies—but use a light touch and don't overwork it.

Dusting

Try the dusting technique for hazy or filmy color. Lay your painting flat, and hold a pastel stick above its surface. Gently scrape a single-edge razor blade along the pastel so that little speckles of pigment rain down on the painting. To set the particles in place, press them into the surface with the clean flat blade of a palette knife. It takes some experience to learn how hard to scrape, where the pigment will fall, and how to press it in. Practice.

Free-Form Strokes

Use every kind of slash and squiggle you know how to make (not all at once, though), and reveal your own artist's handwriting in your work. Free-form marks follow the contour of a form or echo the expressive energy of the artist. They are best used sparingly, as accents.

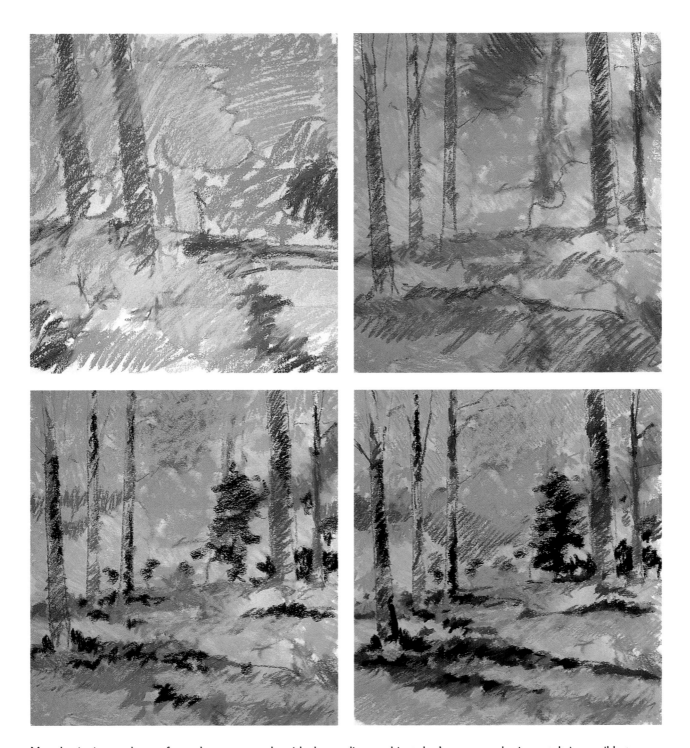

Most beginning students of pastel are too gentle with the medium and just don't use enough pigment. It is possible to build up several layers and keep it all fresh, especially on sanded pastel paper. I began this piece, a workshop demonstration, as a horizontal composition, then smudged the image and turned the paper 90 degrees (to surprise the class) and began a new scene right on top in a vertical format. I added new layers of pastel gradually until the image emerged. Most muddy sections of color can be brought to life with a few well-placed strokes of pure fresh color.

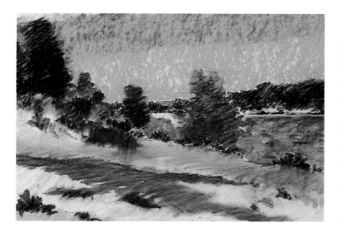

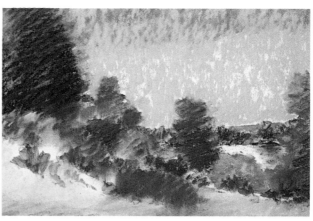

Step 4. Adding more pastel, I soften the sky and also establish the darks throughout the composition. Everything here is still fairly sloppy and smudged.

Step 5. This is important for painters of all levels to notice: There is no need to get too precise too soon; it usually wastes time in the long run. Stay loose as long as you can.

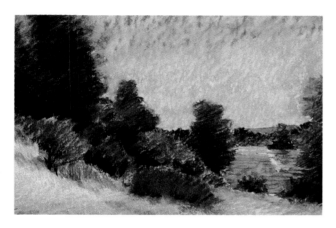

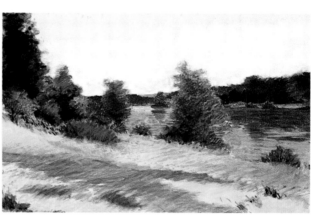

Step 6. I hatch in some deep red and maroon to enliven the green trees. Since my method involves layering, I don't bring any one section to completion yet.

Step 7. I decide to soften the sky considerably, perhaps too much, but I want it to recede so as not to compete with the foreground.

Step 8. Once the sky is subdued, I brighten color in the trees and start including a few branches and sunlit leaves.

Step 9. I drag purple through the river (to unify land and water), then work on the foreground grasses.

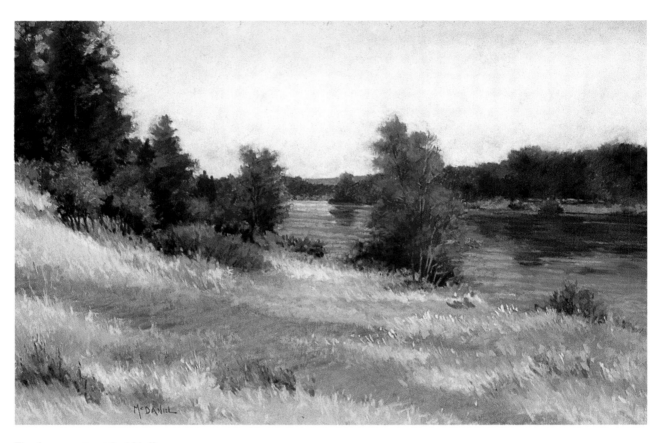

The Sacramento at Red Bluff
Pastel, 9 x 14" (23 x 36 cm), 1993. Courtesy of John Pence
Gallery, San Francisco.

In the final stage, I add accents and highlights. What was
once a big blue "X" is now tempered to a passive shape, a
variation in tone that breaks up the otherwise dry-looking
field of golden grass.

Demonstration:

Using Pastel on a Dark Ground

Pastel is quite forgiving. It can be manipulated and corrected countless times. The only limitation to reworking comes from creating so thick a buildup of pastel that the paper's tooth can hold no more pigment. To avoid this, pastelists often begin on a toned ground, as well as removing any pastel layers before making corrections.

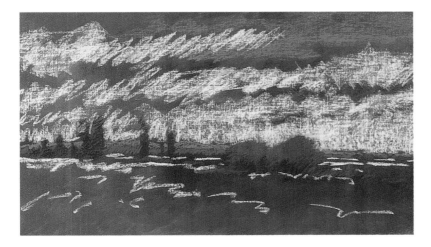

Step 1. I have stained a piece of pastel paper to a fairly deep burgundy color before starting. I make the initial marks with NuPastels, setting up a color scheme of blue and yellow ochre.

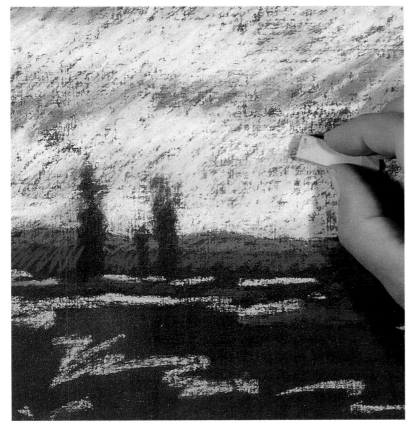

Step 2. Using the side of a hard pastel, I slur in a lighter value of yellow, pulling the previous colors together a bit.

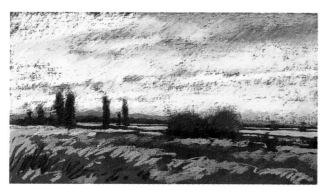

Step 3. Working all over the paper, and staying loose, I let the image evolve slowly, adding some definition to the distant horizontal planes and suggesting some activity in the foreground.

Step 4. At this point, having stepped back to evaluate the painting's progress, I decide to adjust the composition by adding a grove of trees. To avoid excessive pastel buildup, I use a small can of compressed air to remove some sky color where the new trees are planned.

Step 5. I block in the new forms . . .

Step 6. . . . then add some strokes from a soft, rich Sennelier pastel.

Step 7. With soft pastels, I add another layer of sky and more intense color to the foreground.

Napa Serenade
Pastel, 12 x 20" (31 x 51 cm), 1994.

The altered image has a much greater recession of space than the original design, and sets up a better compositional dialogue among the vertical tree elements.

Oil Painting Techniques

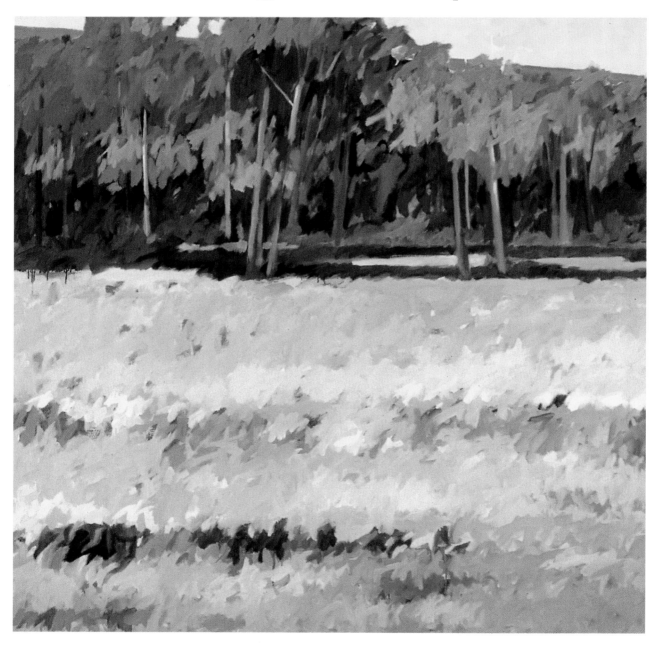

Elysian Field #5
Oil on canvas, 48 x 48" (122 x 122 cm), 1983.
Collection Dr. and Mrs. C. R. Webb.

This has always been one of my favorite paintings. The image is simple, yet there is sufficient variety, and it addresses both the deep space of landscape and the flat space of a two-dimensional surface.

To start with, provided your materials are in order, making a painting is really quite simple. All you need to do is mix the right colors and put them in the right place. Ah, but how do you know where the right place is? Through preparation, experience, a little talent, and lots of practice.

Planning Values

The first and most important step in the painting process occurs without a brush. It is the act of planning the values in your sketchbook. Unfortunately, this is one of the most neglected steps, especially with beginners. Even though some very creative paintings are achieved without benefit of sketching, I believe that all developing painters, and most masters, stand to gain valuable insight through preparatory explorations on paper.

Palette Layout

Set out your palette in an orderly fashion. Place paints along the top/far edge and the sides, leaving the center clear for mixing. Avoid putting color on the bottom/near edge where it may jump onto your shirt. I usually put two blobs of white on the palette, to the right and left of center, to keep clean white available for both warm and cool mixtures.

Many teachers will counsel you to select one particular arrangement and stick to it to save time, because your hand learns instinctively where to go for a particular color. That's logical, but I suggest changing things around every once in a while. If you challenge yourself to work with unfamiliar hues, you are more apt to make new discoveries and develop greater complexity as a colorist. About the only thing I've kept constant over the years is that I usually place my cool colors on the left.

My basic palette includes two reds, two yellows, and two blues (warm and cool of each), plus white. Use these as your minimum, then augment them as I do, with colors such as indigo, burnt sienna, and violet. I always leave space on my palette for a "guest color" or two—enabling me to work with new hues to vary my normal mixing patterns.

On occasion, I start a canvas with only two colors, sometimes plus white. Sennelier makes an indigo and a Chinese orange that I pair up frequently. Another favorite combination is cobalt violet and cadmium yellow light; placed next to each other, the colors really vibrate, but mixed together, they make a strange neutral mud.

Don't squeeze out a little "sky color" on the palette, and once the sky is laid in, put out some "mountain color," and later add some "tree colors" as you think you need them. Set out all your colors at once, and never think that "sky" comes from a single tube.

Squeezing paint from a tube is an art in itself. I've seen students put microscopic specks of color on their palettes (resulting in stingy, tentative brushstrokes and timid paintings)—and at the other extreme, those who squeeze out enough pigment per session to make a color merchant squeal with delight.

Some paints are fluid and come out of the tube quickly; others are slow movers. To minimize trouble, touch the neck of the tube to the palette. Squeeze gently but firmly. Think of expensive toothpaste. Don't squirt out too much paint until you're sure that you'll use it. Normally, the amount needed should be about the size of a heaping dime. You'll need more white though—about the size of a heaping quarter. Make adjustments as needed for very small or very large canvases.

If you have trouble opening a paint tube, hold a lighted match near the neck of the cap, rotating the tube so the cap doesn't burn. The dried oils will soften quickly and the cap will come off easily.

Color Mixing

Mixing color has as much to do with proportions as it has with specific hues. Knowing that a painter used cerulean blue, yellow ochre, and alizarin crimson for a sky doesn't help too much, although I suppose it's a start; the ratio of the three is equally important.

Learn to see relative temperatures within the same color family. Alizarin crimson is cooler than cadmium red, but they are both reds, and therefore "warm" colors. Ultramarine blue is warm when compared to cobalt blue, yet they are both in the (cool) blue family.

Search for grays with character by mixing complements. As you mix greens for foliage, think of temperature. Create warm greens and cool greens, and muted gray greens. Remember that getting the local color of a leaf won't work for painting the entire bush. Look for the effects of light on the leaves.

It isn't always necessary to mix your colors thoroughly on the palette. Some painters prefer to apply partially mixed paint to the canvas for a vibrant, unblended look. The key is to put down the color deftly,

Making colors lighter without white: Far left are burnt umber, lightened with raw sienna, then yellow ochre, then Naples yellow. Near left, indigo is lightened with ultramarine blue, then cobalt, then cerulean.

Mixing grays: Left, cerulean blue and cadmium orange; center, cadmium yellow and ultramarine violet; right, ultramarine blue and burnt umber. White is added to each mixture to provide a variety of values.

without stirring it around too much and muddying it.

If a tube of white seems too cool and lifeless and just doesn't convey the sense of *white,* mix a very, very small amount of cadmium yellow or orange to add warmth. That will wake it up.

You have several choices for lightening a color. White works but often neutralizes the hue, and can even make the mixture seem chalky or heavy-looking. White pigment, when mixed with other colors, will both lighten *and* cool the mixture. As an alternative, pick another color in the same family as the dark color you want to make lighter. Try adding cobalt blue to lighten ultramarine, or to lighten cobalt, try cerulean. Raw sienna will make burnt umber lighter, and yellow

ochre will lighten it further. From alizarin, lighten with cadmium red, then cadmium orange, then cadmium yellow. Obviously, the hue is changing here, too, but that isn't always bad, and isn't too noticeable with adjacent colors.

More than any other aspect of color mixing, your ability to see value relationships is paramount. Temperature, and how you mix the colors, are next in importance, followed by color selection itself. As in many things, it's not what you have that's important; it's what you do with what you have that counts.

It's best to mix up small quantities of paint first to determine the right proportions, then increase amounts gradually. In most cases, it's easier to cool a warm color mixture than to warm up one that is too cool. When painting a sky, for example, begin by placing a pale warm color near the horizon and gradually work up to the cooler hue of the heavens. Doing the reverse (warming up a cool color) may end up a lifeless mud. Wipe off the canvas, wipe off your brush, and start over with warmer color. This will give you better results than trying to push around a glob of the wrong color.

Here are some hints on ways to avoid muddy color: Don't mix more than three colors together at a time, although you can add white to lighten mixtures. Don't mix with dirty brushes or slur color around on the canvas too much; both will cause muddy colors. Don't touch the bottom of your turpentine cup when you dip in your brush. If your solvent becomes dirty, it will affect the brilliance of your paint and color mixtures.

Brushwork

Your personality comes through in your choice of subject, color, and composition, but your own individual stamp, your "handwriting," as it were, is revealed best by the way in which you apply paint.

An experienced artist is one who has developed many different strokes. You should cultivate variety yourself, through practice. Keep the surface of the painting alive through imaginative brush handling. Jab, twist, push, flick, and lift off. Vary the size of the marks, the direction of the strokes, the thickness of the paint, and the clarity of the edges. But remember to integrate all this variety within the overall

Demonstration:

Basic Oil Painting Approach

In essence, this is a re-creation of a workshop demo I did in Old Lyme, Connecticut, when I had no camera to photograph the steps. It was a strange overcast day, almost stormy, and I chose a simple scene to illustrate some basic compositional points, such as simultaneous contrast and interpenetration (discussed in "Composition").

Step 1. This original workshop sketch was done on a piece of humble notebook paper but served well to organize the main shapes and values of the design. Note that the hill is darker than the sky on the right, and lighter on the left.

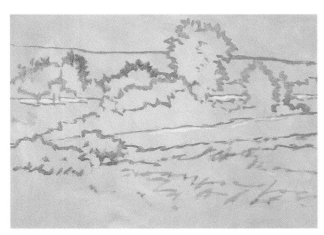

Step 2. On a gray-toned canvas, I lay out the composition with diluted ultramarine blue and burnt umber, adding a little white to remind me about the areas of strongest light. With just a few strokes I have placed the essential lines of the design.

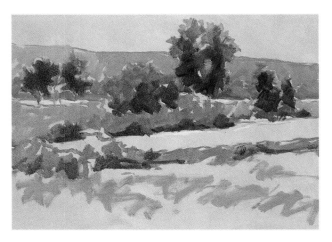

Step 3. Continuing at a rapid pace, I scrub in tonal areas with a bristle brush. These first steps take no more than ten minutes, but now I have the bare bones of a landscape laid out before me.

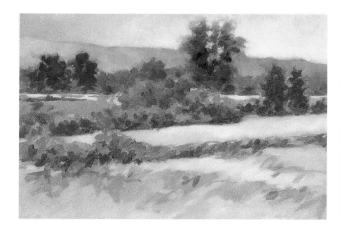

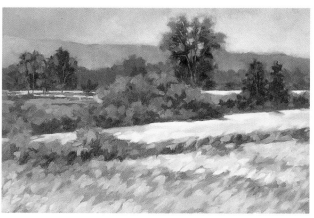

Step 4. I add some higher values for the flat planes, followed by work on the hill and sky—then I stand back and take a break, planning my next move.

Step 5. I decide to add warmer color to the fields, choosing yellow-ochre modified in places with alizarin. Now I add a few details, such as tree trunks and branches.

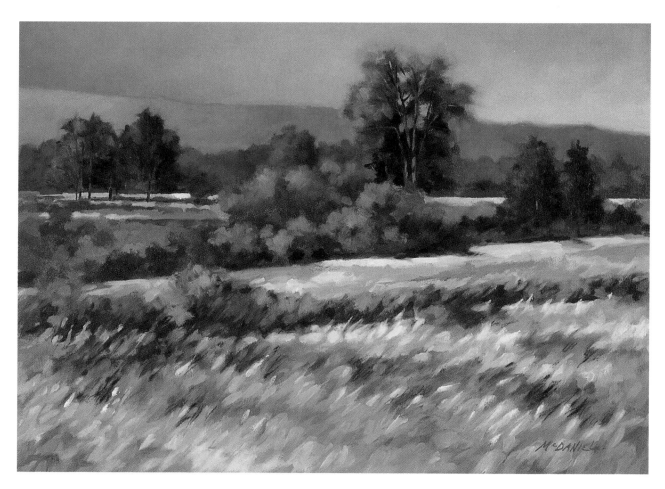

Lyme, Approaching Storm
Oil on canvas, 12 x 16" (31 x 41 cm), 1992.

I repainted the sky and put a few highlights in the foreground. On a day with dull illumination, highlights should not be painted at their full intensity, yet the eye does enjoy seeing a spot of moderately high value in the painting.

Working on a Toned Ground

It is next to impossible to paint a light shape on a pure white canvas and expect to judge its value accurately. Virtually any light mark will appear to be a dark spot when surrounded by white. For this reason, many artists tone the ground to a middle value before they begin to paint. Then a light mark will appear light and a dark mark will appear dark. Neutral gray, ochre, sienna, almost any color will suffice. For fun, try starting out on lime green.

With a toned ground, you can paint the light, which is how we see, instead of painting the dark and leaving the light. Also, when you paint directly on a white surface, not all of the white is covered with a stroke of the brush. On the other hand, color showing through from a wash or a toned ground can add significantly to the chromatic vitality of an image.

Alla Prima or Wet-in-Wet

Alla prima is from the Italian, meaning "at the first" or "first time." The idea in alla prima painting is to get the image down, complete, in one sitting. This is usually accomplished by slurring the paint together wet-in-wet, although many painters use a modified alla prima style, starting with a thin wash and letting it dry before they continue.

Start with a large, light mass, paint each shape a bit

Adirondack Morning
Oil on panel, 8 x 10" (20 x 25 cm), 1995.

Camping on the western shore of the upper Hudson, I used my small pochade box to paint this early-morning view. The sky was just beginning to brighten after an overnight rain, so I painted quickly, wet-in-wet, before the conditions changed.

Austerlitz, April Snow
Oil on panel, 5 x 9" (13 x 23 cm), 1996.

Inches of snow covered the ground one morning after a spring storm. I knew it would melt by noon, but before it did, the warm day gave me a delightful alla prima experience.

larger than it really is, then cut in with midtones. Next, cut into these midtones with darker accents. This is the order for "shaping light areas with dark tones." Keep all of this paint relatively thin; you can then add thicker accents and highlights on top. As you apply color, you must use increasingly thicker amounts of paint.

When slurring colors together on the canvas, superimpose colors of similar values. This will keep the passage under tonal control and you won't have overly active spots of color jumping all over the place. It works well to paint a form just a bit darker than it is, and then to slice in lighter strokes for highlights. It's like pouring liquid light into the image.

Similarly, paint a passage cooler than its local color, then while the paint is still wet, add strokes of local color and reflected color all of the same value (or close) as the first layer, but just a little bit warmer in temperature. You are not trying to warm up the shape by blending the colors together; you are adding broken color that the eye will mix optically.

When painting wet-in-wet, don't fuss with colors that slur together a bit. If a passage is really bad, scrape off the paint and try again—otherwise, leave it alone. Minor adjustments later will fix most things, whereas fussing about now will only cause increased muddiness and will interrupt your creative flow.

Drybrush and Scumbling

A small amount of juiceless paint, lightly applied, results in the "drybrush" effect. This modifies or softens the underlying brushstrokes, but only subtly, since so little new paint is added. The amount of pressure applied with the brush controls the intensity of the drybrush mark.

Scumbling is lightly brushing one color over another so that the top color is deposited on the tooth (surface ridges) of the canvas, allowing some of the color underneath to show through. You can repeat this procedure many times on top of previously dried layers, building up a lively surface. Scumbling should not be used to disguise a poorly painted passage, but only to enhance what is already well painted.

Demonstration:

Oil Painting on a Toned Ground

Many artists find that a toned ground provides an effective background for their needs.
For this particular painting, I wanted to do a snow scene with warm earth color counteracting the coolness of snow. I decided to use a very warm tone as a base to help in the effort.

Step 1. After toning a panel with burnt sienna and a touch of alizarin, I allowed the surface to dry. I then scribbled the briefest of sketches in charcoal and immediately followed with turpentine-diluted oil color to anchor the main components of the design.

Step 2. This may seem like a big jump from the last step, but it is not much more than the application of a middle-value gray for the hills and a very light gray for the sky and snow.

Step 3. Now I clarify a few edges and add details, such as snow in the branches. I stop for the day with most of the image articulated.

Step 4. After evaluating the design, I decide there is a need to modify the tree line and add two tree masses. With a piece of pastel I scribble some notations on the now-dry painting and try to imagine the passages repainted.

Step 5. Before painting each adjustment, I carefully wipe off the pastel lines so that they won't mix with the paint. Once this is done, I stand back and evaluate the composition again.

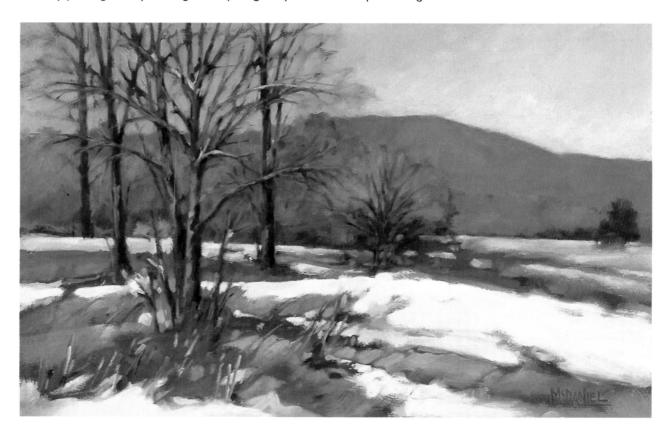

Epiphany
Oil on panel, 8 x 12" (21 x 31 cm), 1994.

Finally, I decide to increase the yellow tint a little and make just a few minor adjustments here and there. When nothing really bugs me, I leave the painting alone.

Glazing

Applying a glaze to a painting is like putting a layer of tinted cellophane over a portion of the image. It adds luminosity and variety and unifies shapes through a common color. A transparent glaze can be casually brushed on in a few selected parts of a painting or can be a component of a complex procedure.

The traditional glaze technique involves a complete underpainting, usually in monochrome, followed by thin glazes of transparent color. More a studio technique than a process for outdoor painting, glazing is nonetheless very useful to nature painters. Artists such as J. M. W. Turner and George Inness used glazes in their landscapes to create glowing effects of light and atmosphere.

Maxfield Parrish (1870–1966), a master of glazing, would paint the entire scene in blue and white, then add veils of color to modify the image. For example, if he wished to create a green bush, he would paint the bush shape light blue, allow it to dry, and apply a transparent layer of yellow paint over it. The light blue would now appear a pale blue-green. After the glaze layer had dried, he would apply another layer of yellow, and another, until the appropriate green was reached. Such a green is more luminous and will show greater color saturation than if the blue and yellow had been mixed on the palette and then applied to the canvas.

As you can see, the glazing process demands thinking ahead and may seem tedious to some, but the results are quite positive. To review in more detail, the artist begins with an underpainting that is allowed to dry to the touch. Paint that is mixed with a glazing formula (oil and / or varnish) is then applied in thin layers. You can apply glaze with a brush (soft sable brushes are good, as they leave the least visible strokes), and then rub it in with your fingers or a lint-free cloth to thin the paint film further.

It's possible to glaze over any color, but the best results are usually achieved when the form in the underpainting is a light or middle value. The luminosity of a glaze is partly due to light reflecting back up through the paint from a light-colored shape beneath.

About half of the oil paints available today are transparent (so labeled by some manufacturers), and

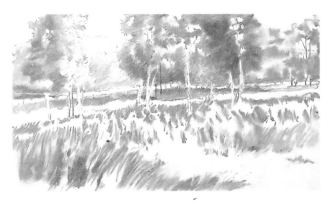

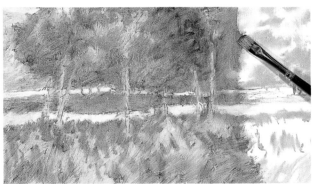

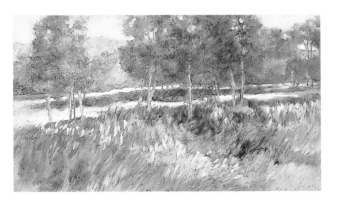

In this sequence, I draw the scene in charcoal and apply fixative. Then I coat the surface with a glaze, wiping out some of the highlights with a rag. The quickly executed charcoal drawing now serves as a base for subsequent layers of color.

most opaques can be made transparent with the help of a glaze medium. By building up an image in transparent layers, you can create paintings of great richness. With a glaze layer, gradual refinements can be made, such as lowering the brightness of one form so the emphasis is increased on a neighboring form.

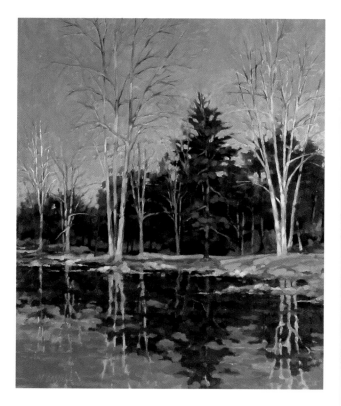

Behind the Studio: Morning Light
Oil on panel, 20 x 16" (51 x 41 cm), 1991. Collection
Dr. and Mrs. Lawrence White.

This spot, just outside my window, is not a pond. It had rained heavily the two previous days and the water was only a few inches deep—but enough for painting reflections. Special tips for painting water and reflections in it are discussed in detail on pages 163 and 164.

Glazing is also helpful to the plein air painter who fine-tunes work back in the studio.

When you look at your landscape indoors, you may decide to make subtle changes, and glazing is a great device for modification.

You will find that glazing in a few places will tone down areas that are perfectly well painted but perhaps a bit too intense for the rest of the design.

Glazing can also be used effectively to unify two or more elements in a composition. For example, wiping a glaze over two rocks will give them a common coloration and yet they can still exhibit their uniquely painted character.

Successful Oil Painting Strategies

• Think *value* before thinking color.

• Don't be too precise, especially in the beginning.

• Avoid an equal distribution of values. Let one be master.

• Create tonal drama. Punctuate a predominantly dark area with light; give a mainly light passage an unexpected dark accent.

• Let light and shadow fall across various objects, interlocking them.

• Paint shadow shapes where they meet the light. Block in the shadow first, then paint from the light mass into the shadow to describe its boundary.

• Create small oil studies in the field and *respond* to them (not copy them) back in the studio, free from the distractions of wind, bugs, and changing light.

• When your paint is still wet, wipe out mistakes with a rag. Don't bury them by overpainting.

• If your paint is dry, use a canvas scraper to deal with an unsuccessful passage.

• Don't overbrush. The more you brush the paint back and forth on the canvas, the duller it becomes. Try to lay down each brushstroke with confidence and don't fuss with it.

• Experiment with many ways of applying paint: fingers and heel of the hand, rags, gloves, pieces of matboard, and anything else you can think of.

• Consider incorporating areas on your canvas where you glaze, scumble, pour and dribble, stipple, scratch and scrape, wipe away, or use collage, brayers, blotting and lifting, and, of course, a large variety of strokes from your brushes and painting knives.

• Many of the above textural effects can add lots of interest to a landscape. But—beware of overdoing it. No gimmicks.

Demonstration:

Oil Painting on a White Ground

What really attracted me to this scene was the massive rock and bright yellow tree on the left bank. I liked the challenge of balancing so much weight and color with the rest of the painting. To counteract the mass and color on the left, I put some strong value contrasts and directional elements on the right. Was it enough? Did it work?

Step 1. After making a few sketches, I started by painting directly on a primed white canvas with very thin oil paint. Before long, most of the image is blocked in, looking like a watercolor sketch.

Step 2. After the wash dries, I go right for the yellow foliage since it will be a major factor in the color scheme. I put in the first layer of sky and start defining the background hill and trees.

Step 3. In the wash layer, I left bare-white canvas for sunlit areas of rock. Now I add body color to flesh out the rock. First, I apply the darkest notes.

Step 4. Middle tones and some touches to the surrounding areas are added now.

Step 5. Next, a few highlights and more work on the water and background. Then I put the painting away for a few weeks in order to gain a fresh perspective. When I'm unsure how to proceed, I usually turn to another painting instead.

Step 6. The yellow foliage stood out too much in contrast with the blue sky. Even though I liked the sky, I decided to change it, which meant changing the reflected color in the water as well.

Step 7. In this detail of the treetops, you can see how overpainting the sky a few times adds a little color vibration where some of the previous sky color shows through, especially where sky meets tree, softening the edge. Note, too, how a few flicks of yellow in the dark tree, then dark limbs in the yellow tree, help pull things together.

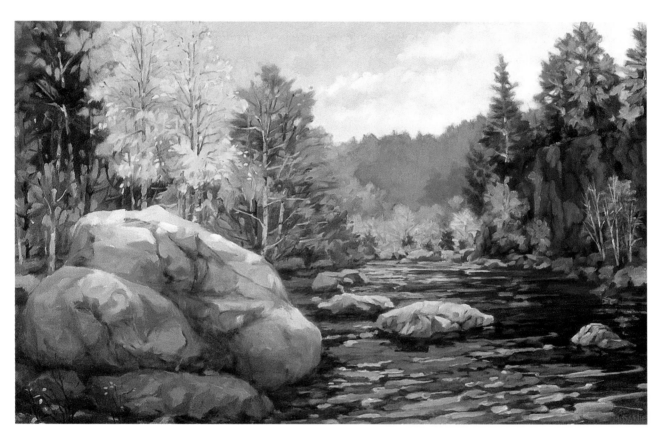

Downriver at Canteras
Oil on canvas, 15 x 27" (38 x 69 cm), 1995.

Although the massive rock and bright-yellow tree dominate
the left side, they are balanced by visual activity on the
right: the contrast of light sky and clifftop trees has empha-
sis; the midstream rocks pull the eye out into the river,
where once again value contrast is strong; and the active,
wiggly quality of the foreground water is sufficiently vibrant
to attract some attention of its own.

Working on Location and in the Studio

To get a real feel for nature when you depict it, you must be out in it. If you work from a photograph of a landscape, it won't bite you like a bug or rain on you, but neither will it smell of eucalyptus leaves nor sound like a gurgling stream. When you work on location, you begin to notice the shapes and rhythms of life, to add to your visual library of landscape images, and to reacquaint yourself with the poetic force of creation.

It isn't necessary to complete a painting on location to derive the benefits of outdoor work. Some artists begin a landscape in the field, receiving the initial spark from nature, then do follow-up work in the studio. Others do quick studies (small oils, watercolors, pastels, or drawings) and later use them to create finished artwork in the studio—especially oil paintings that are too large to complete easily outdoors. To address those situations, the last part of this chapter also deals with how to organize your studio and other aspects of working indoors. But first, let's go outside.

Working in the field presents some tough challenges to the landscape artist, but the rewards outweigh the difficulties. True, the sun won't stay put; you can't bring all the gear you want; what you did bring is wrong and too heavy; your feet are tired; you have three mosquito bites; and you're starving. But it's still worth it, for you've got good results under your arm, and you learned a lot about nature, art, and yourself.

One of the things I find enjoyable about working outdoors is, paradoxically, the hardship. Rapidly changing light, wind, hunger, and bugs tend to make me paint more quickly, and to concentrate only on the important components of a painting. Sketching in the field helps me jump in, say what needs to be said, and jump out. All the little hardships are soon forgotten once the excitement of the chase takes over.

Detail, *Westering Sun,* page 154.

Preparing to Work Outdoors

Lock Creek in Winter
Pencil, 7 x 12¹/2" (18 x 31 cm), 1991. Collection of the
Schenectady Museum, Schenectady, New York.

The shaft of light delineating the slope of the creek bank
was the element that interested me most in this scene,
which inspired my painting on page 93.

It's important to organize your gear *before* you go on
location. Keep it simple, but try to take everything you
need. Experience will show you the difference be-
tween what you *think* you need and what is actually in-
dispensable. If you own a car, it's a good idea to keep
a little mini-kit there—something so conveniently
stowed that it's never in the way, to hold a small
sketchbook and a handful of pencils, an eraser, sharp-
ener, maybe some pens or colored pencils—all in a
compact and durable container, always handy when
you see something worth drawing. I have a friend who
travels by bus and keeps a few index cards and a pen or
pencil in his shirt pocket as part of his daily uniform.
When he wants to make a sketch or jot down an idea,
he's prepared.

Basic Equipment

For oil or pastel painting outdoors, you need a support
to work on (stretched canvas, rigid panel, or prepared
paper); something to prop it against (easel or other de-
vice); and supplies for making the image (paint,
brushes, pastels, etc.). It also helps to keep everything
organized in a sturdy but lightweight container.

There have been a few systems developed over the
years that satisfy all the above needs at once. The
French easel is the most popular example. It's an easel,
paint box, and canvas carrier self-combined into one
portable case. Pochade boxes are even more compact,
can be used on one's lap, or attached to a lightweight
tripod to function as an easel—a good option for
artists who sketch or paint in city parks or other areas
reached on foot or by public transportation. More de-
tails about easels are in "Materials."

Whatever system you use, pack it all up in advance.
It's frustrating to search for brushes and paint tubes as
you rush through some mental checklist, fearing to
forget something critical—while the daylight is perfect
and your urge to paint outside is overwhelming.

Lock Creek in Winter
Oil on canvas, 16 x 29" (41 x 74 cm), 1991.
Collection of Merrill Lynch, Albany, New York.

In this painting based on my drawing on page 92, I was able to accentuate the color temperature and contrast of late-day sunlight and shadow.

Keep your portable easel packed and waiting by your door. The only thing you should really have to do right before heading out on location is to pack lunch and water, dress appropriately, and let someone know where you're going. Oh, yes—it's good to double-check your supplies quickly before you leave, to replace whatever it was that you removed from your paint box yesterday and forgot to put back.

When location painting is central to an artist's life, a "studio on wheels" is useful. I once owned a Volkswagen bus that was factory-outfitted for camping. It became my traveling studio, carrying all my outdoor art supplies, plus camping equipment. That bus (and subsequent trucks I've owned) was great for working in rain, snow, or by dawn's first light. Plein air painting and camping belong together. The relaxed timetable at the campsite combined with the closeness to nature are wonderfully conducive to capturing the landscape.

Painting Supplies

Travel light. Don't take more paint or pastels than you need. When a paint tube of mine gets down to about one-third its original size, with its bottom rolled up like a tube of toothpaste, I get out a brand-new tube for studio use and put the smaller tube aside for out-

door painting. No one needs a whole tube of paint for working in the field, so why carry all the extra weight? For pastels, I have a simple system: I take only a few hand-picked colors in small boxes. When I get back to the studio, I make color adjustments.

A difficult aspect of landscape painting is how to contain a scene when nature has no natural boundaries. It's easy to look at a vista and become overwhelmed. A viewfinder helps beginners and professionals alike. Carry one in your paint box and *use* it. For the sake of miniaturization, I use an empty slide mount as a viewfinder. It's only 2 x 2" but it does the trick, and if you lose one, it's easily replaced.

Other Essentials

Water is the most important extra to take along, but a snack is a close second. Put a few pieces of well-wrapped hard candy in your paint box or pocket. They

When working on location, you want to keep the weight of supplies down, yet travel with enough colors to do the job. Left, I pack small, partially used paint tubes in a cardboard box. Right, short pieces of pastel colors go in separate little boxes for light, dark, and midvalue colors.

A hat will protect your head and shade your eyes from the glare of the sun. Viewfinders help you make sense of the vast landscape, and make it easier to compose the image. Two pieces of L-shaped cardboard make a great viewfinder, but an empty slide mount also works just fine.

can soothe a dry throat and relieve a nagging discomfort that might otherwise send you home early.

Other lightweight items that I carry in my paint box are matches, a pocketknife, an individually packaged moist towelette, and tweezers to remove thorns or splinters from skin or clothing—or to remove stray hair, dirt, or bug legs from a wet canvas (although sometimes it's better to remove such things when the paint is dry).

A palette knife is also a good tool for getting stray objects off of a working surface. Lightweight foam rubber strips or soft padding will keep pastels, or other supplies, secure in a French easel during travel.

Also pack in a small roll of duct tape and an empty plastic garbage bag for used paint rags. And to secure your paint box, just wrap one or two bungee cords around it.

Corot is said to have taken along a square of white linen and one of black velvet when he painted outdoors. He would place them on the ground before him to judge the relative values of the scene as they existed between the white and black.

When portability is not a major concern, some artists take along a compact umbrella to provide shade for the artist as well as for the canvas and palette. Don't use a brightly colored beach umbrella though. You'll find yourself painting under a big cloud of colored light.

Clothing

Dress in layers of lightweight clothing. Pockets are useful. You don't have to look fashionable. In winter, it's especially important to dress warmly. See page 96 for hints on winter painting.

Since light-colored clothing reflects light (and heat), you will stay cooler on a summer day wearing light colors. However, for the very same reason, veteran landscape painters often wear dark shirts to keep reflected light off their canvas. Take your choice but at least avoid wearing a brightly colored shirt. I usually wear khaki in summer.

A hat with a brim is necessary—to keep your head cool in summer or warm in winter, shade your eyes from sun glare, and discourage flying insects from getting close to your face.

Important Outdoor Precautions

Campers and hikers know that adequate preparation can make all the difference between a good and a bad experience. A few commonsense precautions will increase the likelihood that every outdoor drawing or painting excursion is safe and satisfying.

Buddy System

Be prudent; plan your outings with a friend. If that is not always possible, at least let someone know where you are going. I've been painting outdoors for over

Learn to recognize (and shun) poison ivy. The simplest way to avoid a lot of unpleasant itching is to stay away from this little demon.

twenty years without any serious problem, but whenever I venture out into the wilderness, especially in winter, I let someone know my plans.

Poison Ivy

The best remedy is avoidance—so it's essential that you know just what poison ivy looks like. Do study the photograph above and never forget the expression "Leaflets three, let it be." Poison oak also has a compound leaf of three leaflets, is closely related to poison ivy, and equally to be shunned.

Widespread and easily confused with other nonpoisonous plants, poison ivy produces a skin rash in most people who come in contact with it. The plant thrives along sunny beaches and roadsides, on stone walls, and in overgrown fields—just the sort of places an artist seeks out. The "itch weed" also enjoys light shade in wooded areas near parks or reservoirs.

By the way, the leaves of poison ivy are among the first to change color in autumn, habitually forming a red garland that clings arrogantly to the trunks of oak and maple trees.

Lyme Disease

Lyme disease is an acute inflammatory disease transmitted through the bite of an infected tick. The most common carrier is the deer tick, which even as an adult is smaller than a flea. When Lyme disease is treated promptly, the cure is simple and all symptoms disappear in a timely fashion. If untreated, it can cause

very serious damage to internal organs. Early diagnosis and treatment of infection are therefore important.

The best prevention, as with poison ivy, is education and avoidance. In areas known to have deer, be especially careful when walking through tall grasses or underbrush. If you must walk through probable tick habitat, wear light-colored clothing, since it's easier to see a little dark tick on a light background (value contrast!). Tuck your pant legs into your socks. Spray insect repellent on your shoes, socks, and pants.

When you return from painting in the field, it's important to examine yourself thoroughly. If you find a tick, using tweezers, grasp the tick as close to the skin as possible and pull it straight out, then put antiseptic on the bite. If you're not certain that you've removed the tick completely, consult with your doctor or local health department for follow-up information.

Mosquitoes

I have tried many insect repellents, but generally forget to use one at all, so I try to go instead where mosquitoes don't congregate too forcefully. For one thing, they don't like wind, so look for a spot with a gentle breeze. Also, mosquitoes are attracted to dark colors more than light colors, so dress accordingly.

Human Pests

Some of us are less sociable than others, or perhaps more self-conscious about our struggling work, or maybe just unable to concentrate with lots of distractions. For whatever reason, other people can become the biggest pests of all. Usually, the more you talk to onlookers, the more they talk back. I politely stay silent; eventually, they all go away.

William Morris Hunt (1824–1879), who established one of America's early open-air painting schools, became so upset by tourists and students crowding around to watch him paint that he would wear a placard announcing, I CAN'T TALK, I CAN'T HEAR.

Hot Weather

This may sound simplistic, but I mention it here because it's surprising how we forget simple things when we're immersed in our art: If it's hot, try to stay in the shade, wear your hat, and drink your water.

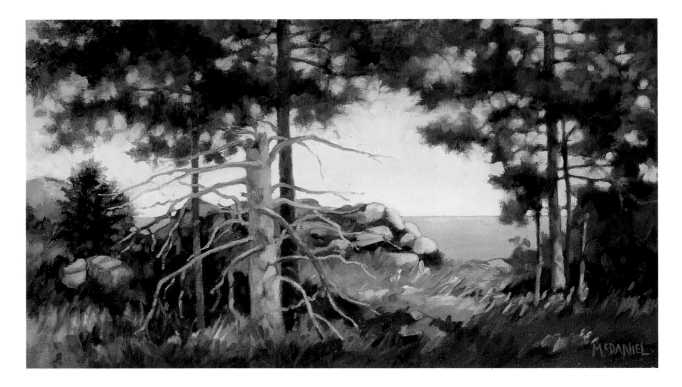

Darkness

The late afternoon, twilight, and even nighttime are superb times to paint. However, if you ever think you'll be out past dark, take your flashlight, dinner, and a friend.

Working on Location in Winter

I enjoy winter location work, but find it hard to take my classes outdoors in cold weather. Some people easily adjust to the cold and are excited about painting a snowscape, while others soon begin shivering and can't wait to get back to the studio. For this reason, most painters work alone in winter, or with a friend of equal stamina. But it is possible that by being better prepared to work outdoors, many more artists would find it a pleasurable experience.

First of all, things that you can practice in the studio or outdoors on sunny days should be mastered then, and not attempted on a cold January morning. You shouldn't be out in the snow learning how to assemble your easel for the first time. Become proficient at setting it up, setting out your pastels or mixing your oils, as well as working quickly and accurately on your painting or sketch before venturing out in winter.

Cliff Trail to Gull Cove
Oil on panel, 7 x 12" (18 x 31 cm), 1994.

My small pochade box came in handy on this hike. Later, in the studio, I applied glazes to add an aura of golden light.

Layered clothing (even include long johns) always provides the greatest warmth. Wearing gloves when you paint will not only warm your hands but will help you eliminate unnecessary detail as you work with pencil, pen, pastel, or brush. Keeping your feet warm also makes a major difference. If you're working in snow, stand on a piece of cardboard, carpet, or better yet, insulated foam. Always keep your head and ears covered. And take a thermos—it's good to be warm inside, too.

Finally, for you hardy souls who venture outdoors with oil paint in subfreezing temperatures, premix some kerosene into your white pigment to keep it from becoming too stiff on your palette. If you are prepared, and work efficiently, there is little that can compare to the exhilaration of drawing or painting out in the snow. When you return home, you'll have an inward glow of satisfaction that is difficult to describe.

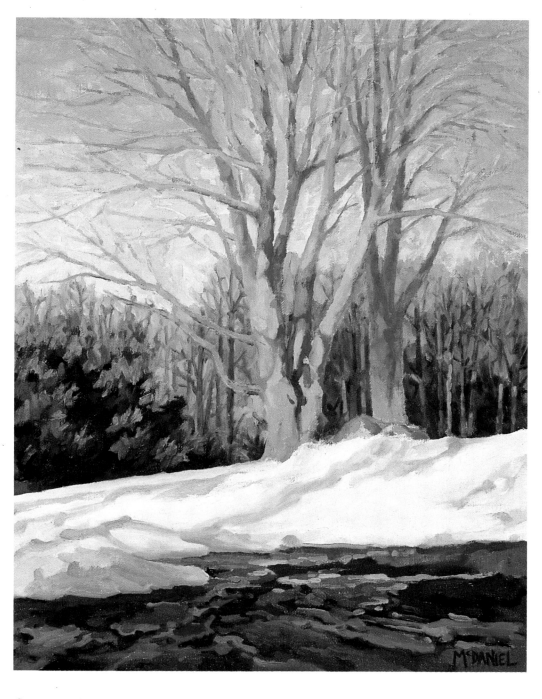

The Bearsville Ash, February
Oil on canvas,
14 x 11"
(36 x 28 cm), 1996.

This is a modified alla prima painting. I began on location, working wet-into-wet, but soon returned to the warmth of my studio.

Coping with Inclement Weather

Be prepared in case a wind comes up that may disturb your easel. Carry an empty cloth bag—or improvise with the container that holds your water or other gear—and weight it with dirt or rocks. Then with bungee cords, attach the bag to your easel to keep it from toppling.

When rain or snow starts falling, there are some dry alternatives to fighting bad weather. Many artists simply drive to a good spot and work in their car; the steering wheel doubles as a makeshift easel. Others work in their studio instead, finding inspiration right out a window. Still another way is to simulate a landscape indoors.

This is a view looking out the driveway from my studio at eight o'clock in the morning (left), two o'clock in the afternoon (center), and an hour later (right), when the sky clouded over. Nothing changed but the light, yet the landscape feeling is quite different in each photograph. Always pay attention to the light; it is just as important as the scene itself.

Collect an assortment of rocks, twigs, leaves, and the like. Arrange a miniature scene, using rocks to represent mountains, twigs and little clumps of moss to stand for trees. To suggest water, place a mirror or a piece of glass beneath your "mountains." Sprinkle some dirt around its edge to create a shoreline. Another way to use bits of nature brought indoors is by doing studies focused on details, zeroing in on particulars such as rocks and twigs.

The most comfortable way to use painting time during inclement weather is to complete work begun outdoors or to begin new landscapes based on sketchbook studies or memory. And never forget the value of working on a still life, which always benefits landscape work. All the disciplines interact, as we know from the example set by masters such as Cézanne and van Gogh, who were both equally skilled at still life, portraiture, and landscape.

Sometimes it's tempting to challenge the elements. In 1976, when I was new to landscape art and filled with the bravado of a young man, a hurricane was sweeping up the Eastern Seaboard to the town where I was living, but I decided to go outside and paint in the storm anyway. I packed up my portable easel and paint box, headed out to the meadow behind my studio, and set up, lashing the easel down with rope.

Looking in the direction of the oncoming storm, I blocked in a simple composition that would soon be dominated by a ferocious sky. As I worked, the sky darkened, the wind came up, and I began to tremble with excitement, my brush active and in full power as the first raindrops fell. By the time the storm's full ferocity became visible and I had the tumultuous skyscape in view, I was soaking wet. "Ah, but it's for *art,* so the water feels great," I told myself.

What I didn't expect was the power of a sudden gust of wind. My painting, with its passionately rendered sky, took off, and is probably still sailing around somewhere.

This brings me to reflect on the word *painting,* both as noun and verb. The noun *painting* flew away and is gone, but the verb *painting,* my act of creating the picture, is something that will stay with me forever. My absolute immersion in the work at hand was invigorating. Let's never forget that the *process* is why we paint. The *act* of painting should be of greater value to the artist than generating canvases for sale.

Choosing Your Location

Select a good vantage point. Put down your gear and spend a few minutes exploring the site. You might even walk around and make a few thumbnail sketches

in your book before you decide exactly where you want to set up your easel.

Avoid Direct Sunlight

Look at the light and determine where the sun will be in two hours. Since it will affect the location of all your shadows, it's worth noting. Try to find a comfortable spot in the shade. If you're near a gently rippling stream, so much the better. The constant sound of flowing water has a hypnotic effect that is conducive to creative thought. I've seen nervous new students settle right down next to the stream and forget they were beginners, producing landscapes filled with sensitivity and grace.

If your easel is not in the shade, be sure that the sun doesn't shine directly on your palette or canvas. The glare reflecting back at you will tire your eyes and may give you a headache, and it's nearly impossible to judge values properly with the bright sun shining on your colors. Turn your easel away from the direction of the light source—both direct and reflected light. Adjusting the position of your easel will often help keep your work surface out of the sun. Sometimes this adjustment will cast a shadow on your palette, also keeping it free from glare.

I remember learning about sun glare the hard way when I first began painting outdoors. I was having a grand time, painting a landscape and simultaneously working on my suntan. My palette was fully illuminated by the sun and as I mixed color for the painting, nothing seemed dark enough. I was mixing phthalo blue and alizarin full strength from tubes, trying to find the right value for my shadows. I considered adding black to all my mixtures, but even black paint didn't seem dark enough. Of course when I took the painting back to my studio and looked at it under normal light, it was horrible. It had no sense of light, no subtle shadows, and the darks all looked like black holes.

Consider Changing Light

Both the intensity and the direction of the light will change, no matter how much you will it all to stay the same. When light changes, remember that your entire composition can change too. Countless paintings have been ruined when an artist dutifully toiled at the easel all day long rather than switching to another canvas. If you plan to paint outdoors all day, consider working on one image for morning light and another for afternoon light.

Whether you're sketching, painting, or using pastels, you must learn to see shapes and colors quickly and simply, before light patterns change. In order to convey the drama and nuance of natural sunlight and shadow, you may find it helpful to exaggerate the warm-cool contrast in outdoor painting. Pigment in oils and pastels is not the same as real light, so we must approximate it by accentuating temperature and value contrasts.

Quickly establish your design and note the position and coloration of the shadows. Although the shadows will change, stick to the design in your painting; don't chase the shadows all around the composition as sunlight shifts.

Spend careful time selecting, arranging, eliminating—then work fast. It's good for you, not bad for you. We're often forced by circumstances working outdoors to make decisions quickly, and to include only what is essential to the composition. As van Gogh once said, "Exaggerate the essential and leave the obvious vague."

Respect the Setting

About gates: The country rule is, "If it's open, leave it open; if it's closed, leave it closed."

Always leave a site clean. Cows get sick if they eat a tube of paint. Artists and farmers or ranchers have coexisted for years and years, but the continuing hospitality of landowners depends on artists showing the proper respect for property and privacy. Farmers don't like to find paint rags, spilled turpentine, and soda cans on their land after the easels have been packed up.

In summary, despite some extra effort and problems that outdoor work may present, you will discover that painting on location is a great vacation from day-to-day routine. When I'm out there, I forget about the mortgage, deadlines, current events—the *only* important issue is balancing that little red-violet spot in the upper left with this blue-green shape in the foreground.

Demonstration:

Location Painting on Masonite Panel

I painted this image on location in California's Sonoma Valley. The view is to the west, almost directly into the afternoon sun, which accounts for the light sky and the shaded grove of trees in the middle distance. The scene is backlit.

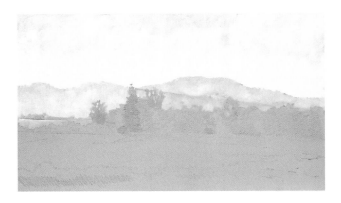

Step 1. I begin on a small Masonite panel, gessoed and toned to a neutral gray. After scribbling some guidelines in charcoal, I use Naples yellow and the very smallest touch of indigo for the sky and hills.

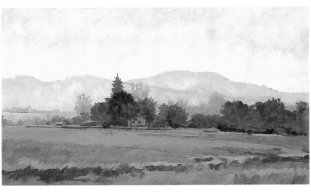

Step 2. Having set the mood of warm, hazy light, now I scrub in some of the dark colors so as to establish the tonal boundaries for the painting.

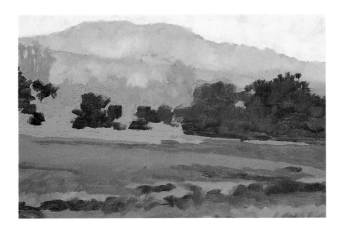

Step 3. Within a short time, I have the panel covered and can see how my composition is (or isn't) working. Standing back to evaluate the basic design, I allow the first layer of thin paint to dry for a few minutes.

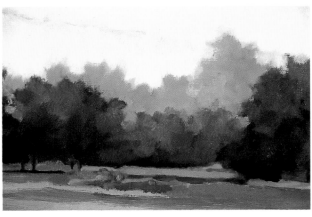

Step 4. Notice the reliable, basic strategy employed here: It's easy to suggest atmospheric depth by making shapes lighter and less distinct as they recede into the distance.

Working in the Studio

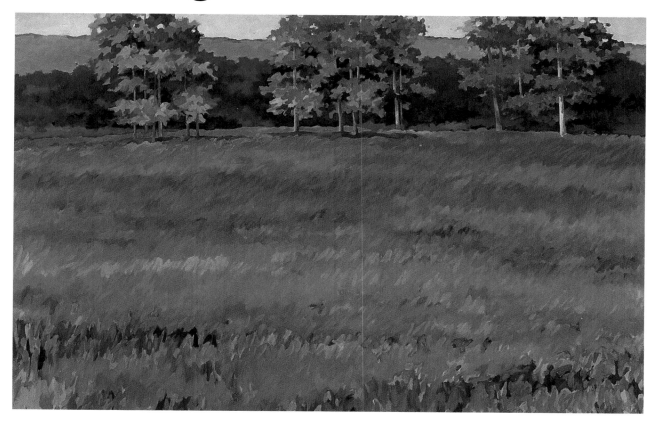

Elysian Field #3
Oil on canvas, 30 x 44" (76 x 112 cm), 1983.

This is a painting about color and rhythm, with landscape imagery providing a subtext. The field of color must be crossed visually before reaching the distant trees—much like crossing a meadow to reach the shelter of the woods, perhaps a metaphor suggesting tasks in life and their forthcoming rewards.

Surprisingly, the creation of landscape art happens largely in the studio. Even work begun outdoors is often modified in the privacy and neutral atmosphere of the studio. The landscape artist also needs indoor space for preparation work and storage.

I've built three studios in my life and arranged several painting spaces in various household rooms (spare bedroom, dining room, even a kitchen) when no real studio was available. I've also rented painting space

and utilized studios at schools and art colonies. Every work environment is different, yet I've observed some similarities common to all.

One universal characteristic is, no matter what the size, studios are all too small. The space problem is not so much in the work area, but in lack of storage space for all the stuff an artist needs. The maxim that comes into play here is: "Clutter expands to fit the existing space." But regardless of room size, or the amount of your clutter, it is important that you have some space reserved exclusively for your artwork.

Setup Tips

To help prevent sore feet, put a carpet scrap on the floor up to your easel. The carpet should be a neutral color (as should studio walls). Once I had to make temporary studio space in a dining room, on top of good carpet. I laid down large sheets of corrugated

cardboard, seamed together with duct tape. It protected the carpet and was easy on the feet. A wood floor is better for your legs than concrete. Wood has a slight flex, or give.

Many beginners tilt their easels back too far. In fact, it's good to tilt an easel forward a bit, which reduces glare. If you're working on a pastel, that angle will stop pastel dust from running down the front of the image as well.

Hang a large mirror in your studio opposite the easel. This is a good device for checking your composition. As you work on an image, you get used to your mistakes, but seeing the painting in reverse will point them out to you. Some artists even carry a small pocket mirror for use when working on location.

If you use artificial light in the studio, try bouncing the light off a white ceiling. If your ceiling is too high or is a color other than white, suspend a white sheet above the easel and aim the lights at the sheet. This provides even illumination and is easier on your eyes.

Never paint directly beneath an overhead lamp. The light picks up the tooth of a canvas and reflects the sheen of wet paint back at you, causing eyestrain and incorrect reading of values. Plus, when the painting is illuminated so brightly, you see too much detail, and dark passages appear too light.

If you can, put some lights on a dimmer switch; it helps you evaluate your work. Less detail is visible, so it's easier to judge major shapes and value relationships. I created a separate "viewing room" in my studio, installed racks there to hold completed work, and placed a bench about twelve feet back from the end wall. A bank of spotlights in the ceiling are on a dimmer and can shine on any painting hung on that wall. Such a setup is ideal for showing completed art to guests, but is equally handy for viewing works in progress. If you turn the lights down to their lowest setting, simulating candlelight, the effect is almost like squinting.

One of my most useful studio accessories is my green box, a small, sturdy wood box that I found in an old tool shed. It measures 7 x 10 x 16". I keep it next to my easel, where it acts as a footrest of three different heights, or as a 7" platform—often just the extra elevation I need to reach the top of a large painting. If I want to work near the bottom of a painting, it also functions as a stool at three heights. The box is easy to kick into position, since it's open at one end, so I can hook a foot into it and flip it around. I've had this box for twenty years, and it has really become a constant companion.

Studio Procedures

Indoor work is of great benefit to the plein air artist. It provides an opportunity to rehearse image-making without the added burdens associated with outdoor work. The essential difference between the two environments is this: Plein air work is good for inspiration and direct observation, promoting authenticity and discouraging us from making commonplace images, whereas studio work is ideal for planning and developing intricate compositions and employing a full range of procedures, such as glazing, overpainting, and recomposing.

Because all materials and creature comforts are readily at hand in the studio, this very convenience may cultivate stale images without the input of direct observation—which is why many artists start a landscape outdoors and finish it indoors. Except for the in-

Près de Charmont
Pencil, 4^1/2 x 4" (11 x 10 cm), 1991.
Collection of Candace Raney.

This abbreviated sketch of the countryside northwest of Paris served as a spark for two paintings.

terruption, they feel this is the best of both worlds. But the interruption can even be beneficial to the creative process, for it introduces a period of gestation, giving the artist time to step back and reflect. Let's not forget that we aren't shackled with the responsibility of recording nature like a camera; our duty is to interpret it.

To expand on a note made earlier, another studio procedure is to use outdoor sketches (color or black and white) by responding to them indoors on an entirely new canvas. This allows a considerable amount of freedom to recompose, whether the final image is realistic or abstract. To invent landscapes convincingly in the studio, you must observe enough effects out in the field. Fill your memory with the characteristic incidents of nature and it will lend credibility to the imaginary passages you put in your paintings.

Keep several pieces of art going simultaneously. Most artists I know work this way. By having many

This is an image from my sketchbook that I used as a point of departure for the red painting on page 105.

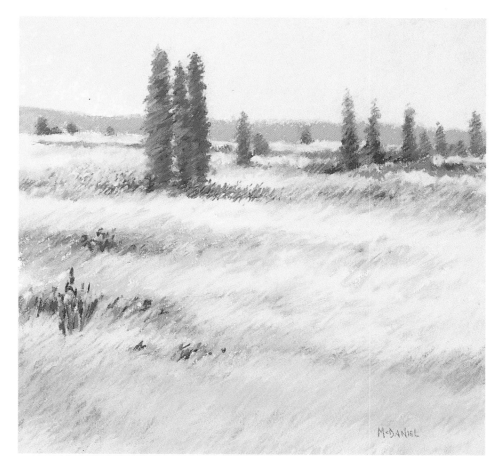

Près de Charmont
Pastel on Wallis sanded paper, 10 x 10"
(26 x 26 cm), 1996.

I pinned the drawing to my studio wall and responded with pastel in my initial exploration of color.

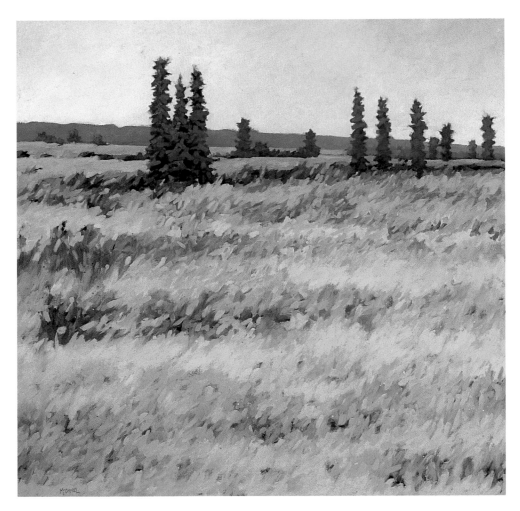

Champs de Charmont
Oil on canvas, 44 x 44"
(112 x 112 cm), 1996.

Having made a pencil
sketch (page 106),
then a pastel painting
(page 107), once I
switched to oil, I was
already quite familiar
with this image, and
concentrated on the
dynamics of color and
the rhythm of the
brushstrokes.

paintings at various stages of completion, you can always choose work to match your state of mind. When you're in the mood to start a new piece, do so—but other times, you'll be glad to have something already cooking. Not every painting has an easy birth. We all have some that fail and fail, and then just sit in the corner of the studio, neglected and unloved. Then one day, perhaps a year later, you'll take a painting out, glance at it, and know in a heartbeat what needs to be done. The ugly duckling grows up to be a swan.

I knew a painter who struggled relentlessly with a single piece at a time. She would tell me how she disliked a canvas but felt chained to it, and would not give up until she was through. Only then would she move on to another image. The result was a constant supply of competent but lifeless paintings. However, every time she "played hooky" and broke this pattern, she would create stunning drawings and small paintings. Fortunately, she finally overcame that burdensome struggle-with-one-work ethic and is much happier with her broadened studio procedure.

For the sake of efficiency and freshness, try doing three paintings at once. I don't mean that you should work on them with brushes in each hand simultaneously. Work sequentially, and don't create three copies of the same scene; concentrate on making each image unique and strong.

Formulate your ideas first on paper as you come up with three different designs. For the next step, when you are loosely blocking in your pastel or oil painting, while your mind is loose and your arms are loose and you're in the mood to splash big shapes around, why stop after blocking in a single canvas or sheet of paper? Do three.

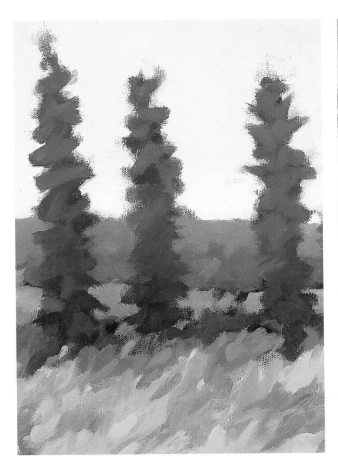

This detail shows calligraphic brushstrokes reminiscent of the rhythmic strokes in the original drawing on page 106.

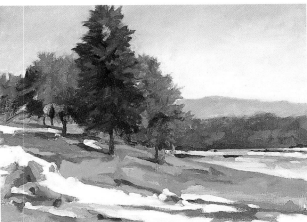

In this instance, the preliminary sketch was done with paint rather than pencil. Color notations and the basic flow of the hill prompted the pastel painting on page 166.

Continue through the various phases of your procedures, bringing all three works along gradually. It's the same principle as developing one canvas over all, never getting too detailed in one spot while the rest of the image is still unresolved. You'll eventually spend more time on one of the three without jumping to another. Good. Having three pieces going at once can be especially helpful if you're working in layers and drying time is a factor. With three, there's a greater chance that you'll always have a dry painting to work on. This simple studio procedure promotes momentum and consistency. If all goes well, you'll complete work in trios, with a uniform viewpoint.

With these and all other work that you create, I suggest that you place your identification on each piece. Print your name on the back of a canvas with charcoal. Ink can bleed through. I include the size of the painting and a date code number. My code is as follows: The first two digits refer to the year of completion, the last two digits refer to the sequential order in which the piece was done. Therefore, 9508 is the serial number for the eighth painting I finished in 1995. Drawings are preceded by the letter *D* and pastels are preceded by the letter *P.* I record this simple information in a notebook as well.

Understanding Your Artistic Personality

There are ritualistic and nonritualistic painters. Few of us are entirely in one camp or the other but swing back and forth. It doesn't matter which you tend toward more often, but knowing your bent will allow you to work with your strengths.

A ritualistic painter prepares for a painting performance. Like the sumi artist who grinds his ink as a form of meditation before painting—a transitional stage between the everyday world and the world of art—many artists go through a cleansing ritual before they work. They clean their palette, arrange their brushes, lay out colors in a methodical arrangement, and make certain they have uninterrupted painting time blocked out.

Once a ritualistic painter begins, the work is clear, concentrated, and to the point. Be aware of the down side, though, for the wolf of procrastination likes to hide in the sheep's clothing of ritual.

Summer Solstice
Oil on canvas, 24 x 30"
(41 x 76 cm), 1992.

Although this image is far from photographic, a sense of landscape space is still suggested. I developed the painting from abstracted sketches I made while riding on a train. Had I used a camera, the concept would have evolved in an entirely different manner.

Nonritualistic painters can jump right into work with no warm-up. Sometimes the artistic frenzy is so intense that their studios look like war zones—it's impossible to find anything. But a nonritualistic painter can walk into the studio with only ten minutes of free time and get something done.

How I envy that quality. I waste at least eleven minutes before I can do a thing. But I've known fine artists who spend many hours in the studio before they get their engines started. Once they get going, they'll paint for ten hours straight. In fact, the more I speak with other artists, the more I realize that we all have our own little quirks and "creative blocks," and the best thing is not to chastise ourselves over them. Be yourself.

Work Habits

I like to paint every day, but life intrudes. I usually paint daily for a week or two, then stop for a while to attend to mundane needs. For those who hold other fulltime jobs or have other responsibilities that must take priority, painting time has to be squeezed in whenever possible, perhaps only once a week. But whether you paint daily or only occasionally, you should adapt your studio habits to your available time.

For example, when I paint every day, my work habits differ from those of an occasional painter. I don't clean my palette. It's a trick I use to get started the next day. On entering the studio, I scrape the palette clean, and before I know it, I've put out fresh paint, which I can't let go to waste, so I pick up a brush.

At the end of the day, I wipe off my brushes, swirl them in solvent, and leave them, bristles up, in an empty can near my easel. The next day I swirl them in solvent and they're pliable enough to continue painting. If I were to leave my brushes like that for a week, they would not be happy.

About Photography

Photography can be a real help to the landscape artist. While there is some stigma attached to using a camera's eye instead of one's own, there are times when the proper vantage point isn't in a safe or convenient place to set up an easel. Other times, you'll be in the midst of drawing and turn to discover three potential paintings behind you. Out comes the camera to capture your impressions of the scene before the light has changed.

While there is nothing like painting landscapes from life to develop an understanding of nature, once

an artist has worked in the field enough, it becomes much easier to use photographs creatively, to compensate for inaccuracies of color, depth, light, and perspective. But a photo is only a starting point; even photorealist painters change their source material. Still, many instructors caution against using photos, fearing that the camera will become a crutch for students who have not yet learned how to draw from real life. That is the problem in a nutshell: Photos won't help a student who has not developed skills and artistic insight. But if one can already draw, photographs can be valuable tools.

I seldom use photographs in my work in the direct sense. But I enjoy cameras—especially ones with a zoom lens—for composing and framing scenes. Often, I just look, but don't snap the shutter; viewing is enough. Other times photos are useful for recalling not only details of a locale, but also its general ambience. This memory jog may prompt a new walk in the woods, with the purpose of painting the same or similar scene. So I keep a file of prints separated into different categories (local summer, local winter, France, Alaska, doghouses) and look at them to refresh my memory concerning atmosphere or specific details. Of equal or greater importance are my sketchbooks and file of drawings, which I also use for reference. They have the added advantage of including my own artistic personality and a record of the emotion I felt when I made the sketch.

No camera lens is as sophisticated as the human eye. A camera cannot record precise detail in both dark and light portions of a scene at the same time. Some colors also reproduce with difficulty. If you've ever tried to photograph blue morning glories, you'll agree that the magnificence of the flower just doesn't transfer to film. Photographs also create distortions with linear perspective, especially large objects shot at close range, and shapes appear to undergo a certain amount of flattening on film. And, of course, the biggest difference between our active eyesight and the passive sight of photography is the fact that a camera has no brain. We are selective in what we see, in what we choose to accentuate, but the camera makes no such decisions. It records everything with equal emphasis, important or not, making no aesthetic or emotional judgments. Our task as artists is to make those emotional and aesthetic decisions. If we use photography, we must not cease to think creatively.

Using Photographs Effectively

Infuse your work with vitality and character first, and use photographic resources as a tool, but never as a guiding star. Here are some suggestions:

• Use black-and-white photos for value and shape, but add your own color when you paint.

• Photograph different exposures of light and dark areas to have a fuller record of values in the scene.

• Work from several photographs, selecting only portions of information from each.

• Try cutting and pasting a few pictures together to create new compositions, but watch out for consistency of light.

• Look at a photograph and make a drawing from it. Make another one. Now put the picture away and paint from the drawings. Consult the photograph only when necessary.

• Pin or prop your source material (the photograph, the drawing, or both) far enough away from your easel so that details are diminished. This will vary with individuals, depending upon eyesight, but try to put some distance between you and the photo. Don't pin it up on your easel or hold it in your hand.

Records of impressions: sketchbooks and a photo file.

Critiquing Your Artwork

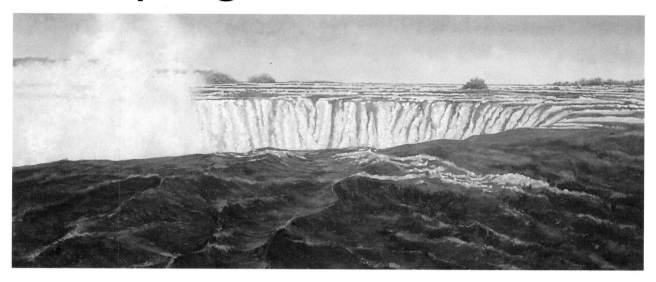

Niagara
Pastel on sanded paper, 14 x 22" (36 x 68 cm), 1991. Courtesy of John Pence Gallery, San Francisco.

This is one of the few perspectives where I could portray the waters rushing toward and away from the vantage point at the same time. My challenge was to paint this movement and not give in to the incipient sensation of vertigo that I had to battle.

Renoir once declared that a painter's armchair is his most important tool, suggesting that the evaluation process is crucial, and time spent analyzing work is as vital as time spent putting brush to canvas.

We may sit in our creative "armchair" before, during, or after the image-making process. The analysis of work in progress begins during the rough draft or blocking-in period of an artwork, when most evaluation is brief; the design is still in flux, and we look to the future, asking, "What should this become?" rather than "What has it become?" We look at a preliminary drawing and judge the major shapes and abstract value patterns of the emerging composition. Once the painting process is in full swing, we step back from the canvas occasionally to check on how things are going to see if we are following our game plan, or if we need to make adjustments.

But it is later, when an artwork has taken shape, that a critique is indispensable. There is now enough graphic information for specific judgments to be made. It's time to step back and examine the work objectively, to judge it for its artistic merits.

The burden in critiquing one's own artwork lies in our psychological investment in the work, and our tendency to adapt to its idiosyncrasies. Our mind and eyes have become so comfortable with the image that we are accustomed to our mistakes. Indeed, the longer we look at something incorrectly painted, the greater is our inclination to see it as correct. We remember so well the hours spent rendering a certain rock that we hesitate to remove it, even if doing so will improve the painting.

At times like this it is wise to employ any and every device available to see the artwork anew. Mistakes become evident if we look objectively, as if we were seeing someone else's painting.

Ways to Help Objectivity

There must be a zillion ways to critique work, a few of which I've already mentioned. Here's a review of those and some other ideas to start you thinking.

• Squint to eliminate detail; you'll view basic elements more clearly and see if your design is strong.

Woodstock Winter
Pencil on museum board, 11 x 9" (28 x 23 cm), 1989.
Collection of Marge and Harry Phillips.

Always have your sketching materials with you to take advantage of landscape opportunities.

• Stand back. One of the most helpful ways to evaluate a composition is to move back from the easel.

• Stand *way* back. Move back so far that the painting becomes the size of a postage stamp. Look at the design. Advance slowly ten paces, and stop. Look at the design again. Each time you advance ten paces and stop, more details will become evident, and at each stopping place you will have an opportunity to determine whether or not the painting is working.

• Turn the work upside down or on its side. By distracting your attention away from the narrative aspect of a picture, it's easier to focus on abstract elements of balance, color harmony, and so on.

• View the work at an oblique angle. By distorting the image, you will be better able to see the interaction of shapes.

• If you stare at a point just to the side of your painting, and not directly at the image, your peripheral vision will simplify the composition.

• Turn binoculars or opera glasses around backward and look through them. It's like walking far away from the easel without moving—particularly helpful if you have a small studio. An artist's item called a reducing glass produces the same effect.

• Look at your work in a mirror; shapes are reversed (as on page 114); and what once was familiar no longer is. If you have become accustomed to your mistakes, they may stand out clearly when viewed in reverse.

• Use colored filters. Optic yellow or blue glasses, polarized sunglasses, even three-dimensional glasses work well (cover the blue side, then the red side to see how your work looks). A colored filter cancels out some of the colors in your painting, thereby emphasizing others, providing a fresh look at the image. Try colored cellophane or Plexiglas. Looking through a filter reduces all colors to values, like a black-and-white photograph.

• Take a Polaroid snapshot. Seeing a painting reduced to a flat piece of paper the size of your hand puts it in a different context. The camera won't reproduce colors and values correctly, but sometimes the shift of emphasis may alert you to new possibilities.

• Take a black-and-white photo. Experiment with color by using nylon-tip markers on the photograph.

• Color photocopiers give you added flexibility. Try cutting out shapes from one copy and rearranging them on another. Reassemble the image and make a new photocopy. Some machines allow you to enlarge, reduce, or reverse the colors.

• An obvious extension of the photocopy process would be to enlist the aid of a computer. The possibilities there are endless.

• Work in another medium. Adapting an image to a new medium can help you to see and critique the first. Redo an oil painting in pastel, or vice versa.

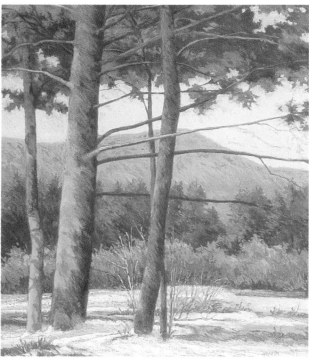

Woodstock Winter
Pastel on sanded paper, 20 x 17" (51 x 43 cm), 1989.

Mirror image.

With a tonal drawing as my guide, it was a simple step to expand my concept and switch to pastel.

• Stick a loop of masking tape to the back of white paper cut to the shape of an element in your painting. Color the shape with pastel to test out new colors. Look at the work from a distance to see if the change will improve your composition.

• Frame it. Pastels and drawings look different once they are surrounded by a mat. Keep a few inexpensive mats in your studio for this purpose.

• Alter the setting. Certainly a different environment or different lighting conditions will affect what you see or don't see in a composition. Take your artwork off the easel and put it elsewhere for a critique. If it's possible, use a room with lights on a dimmer switch. Turn the lights down low until you can barely make out the scene. From this "candlelight" illumination, gradually increase the light, stopping at various points to examine the composition in ever-increasing detail.

• Take a break. The mind-set for evaluating work is slightly different from that for creating work. Switching over to another activity helps to realign your thought processes.

• During your break, sit down with a notebook and record your critiquing ideas. Sometimes I stick pieces of masking tape to the surface of a dry oil painting as reminders. Back at the easel, I pull off a piece of tape, make a correction, then move on to the next piece.

• Work on something else. Time is one of the best ways to gain a fresh perspective on anything. Work on something new and become saturated with the new image. Returning to the first painting after a week, a month, or a year may make everything clear. If you have the friendship of a fellow artist whose insights and opinions you trust, help each other out—and be honest.

Demonstration:

Studio Painting from Location Sketches

Many landscapes are painted in the studio from sketches, imagination, or even photographs. In my opinion, working on location is a tremendous teacher, and the best way to really understand nature. But the art experience need not be confined to direct observation. Often it is in the studio—away from the distractions of wind, changing light, and fatigue—where the artist is free to assimilate his or her impressions, allowing new levels of creativity to emerge.

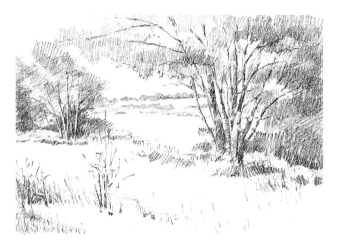

Step 1. This is my location sketch. It's from a real time and place, though I did alter the arrangement of the trees somewhat. True, I could have made it up in the studio just as easily.

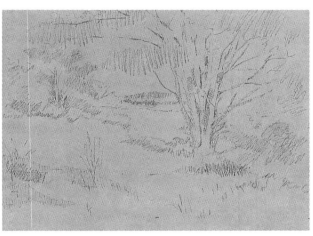

Step 2. I transfer the main elements of the drawing to a gray-toned canvas, using soft vine charcoal.

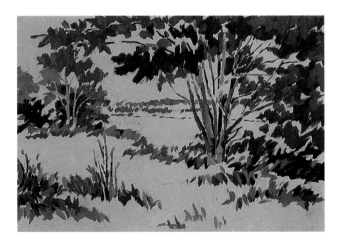

Step 3. Following a common procedure, I brush in some dark shapes, using a combination of burnt umber and ultramarine blue.

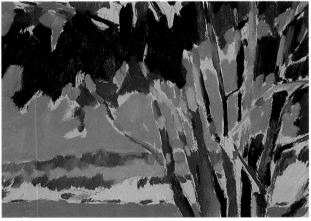

Step 4. Keeping the paint thin, I add a layer of sky and a few warm touches of sienna and ochre. I work quickly and don't worry about retaining precise contours.

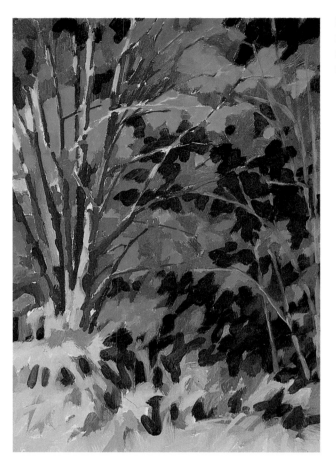

Step 5. The tree begins to take shape as I mix ultramarine and ochre, making a few greens to put on top of darker foliage shades. Nothing is very bright yet, and smeared edges are of no consequence at this time.

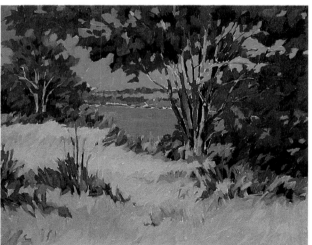

Step 6. In less than half an hour, I now have the essential composition before me, albeit with no real sparkle. This is deliberate, for I will add life later as I progress. For now, it's easier to compare dominant shapes and rearrange where needed if I don't have a lot of time and emotional energy invested in nicely rendered details.

Step 7. Using a moderately small bristle brush (Silverstone No. 2 bright), I poke in new sky color around the branches, allowing some of the previous sky layer to show through.

Step 8. After repainting the sky, I straighten out the shoreline and give another coat of blue to the water to intensify it a bit.

Step 9. Now it's time to give detail and warmer color to the trees and foreground weeds. I decide to add a few tree trunks to support the foliage mass on the right, but keep them subdued in color so as not to attract too much attention to the outside edge of the composition.

Step 10. Working in the upper-right section of the painting, I go back into the treetops and add some new sky, once again letting the previous layer show through in places, forming a network of subtle twig shapes.

Step 11. When I lighten the sky, I pull some of the color down into the river to suggest ripples and to reinforce the horizontal plane of the water. I define more branches in the trees and work on the far bank of the river as well.

Step 12. Turning the painting upside down, I evaluate its abstract shapes and find that the foreground is not unified enough with the sky, water, and trees. The "top" and the "bottom" don't hold together to my satisfaction.

Step 13. I apply a glaze of alizarin and indigo to create a shadow leading back near the side of the main tree. This way, a slight change of direction is required to follow the shadow and then ascend into the branches.

Step 14. Once the glaze is dry, I add some highlights that cross in front of the shadow in the foreground. Then I stand back for a final, overall look and evaluation.

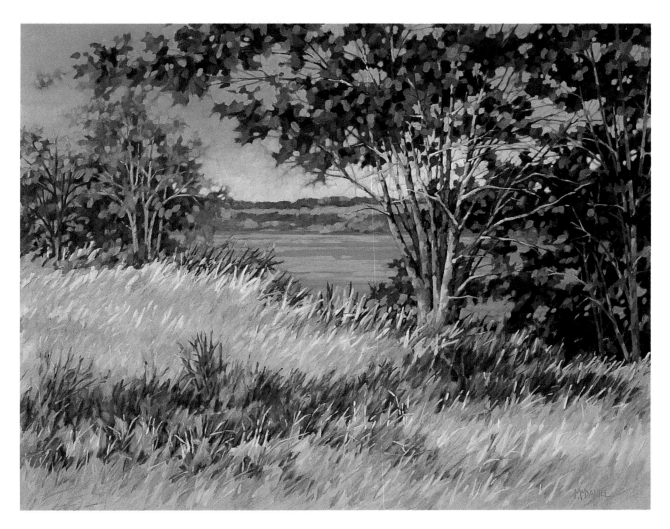

The Sacramento River: Redding in June
Oil on canvas, 16 x 20" (41 x 51 cm), 1992. Courtesy of
John Pence Gallery, San Francisco.

Although the painting began from a sketch of a specific
site, it soon had its own life. That is, I looked at my painting
in progress and projected myself into its imaginary space.
I then made changes on an entirely abstract level to arrive
at a stronger image. While this particular painting does not
stray too much from the original concept, I felt absolutely
free to do so if necessary. There is no reason not to
remove trees or "grow" new ones for the sake of the
composition.

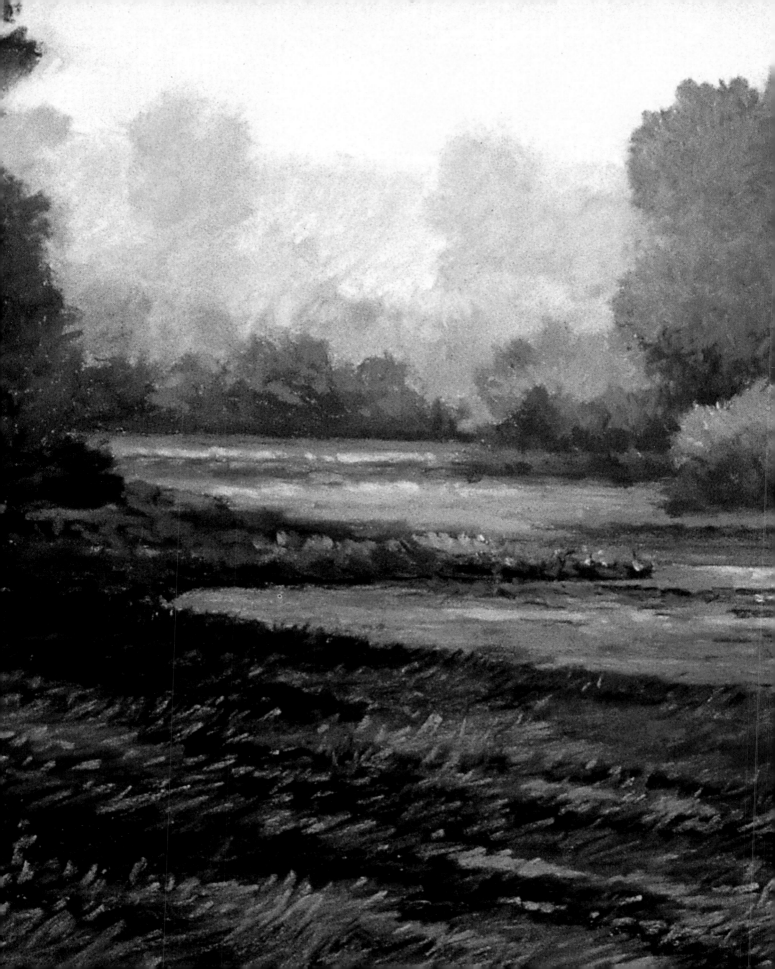

Composition

Nature is a vast storehouse of landscape images just waiting to inspire you. But you must make a selection from all that you see and then build an artistic arrangement of those elements into a composition.

Good artists, whether they are painters, poets, or musicians, strive to achieve a balance between form and content. Control of the artwork's structure is its form, its composition; the free expression of ideas is its content, its message. One might argue that the message is more important than its delivery, but remember that it is delivery that makes a message clear or unclear, persuasive or dull, or perhaps not noticed at all.

Good design is somewhat intuitive, yet it can be learned and improved. An effective design resonates with the viewer's sense of logic and proportion, and though this thought process may be so rapid as to seem subconscious, the viewer nonetheless makes an intellectual connection with good design. The mind is engaged, seeking harmony as the eye darts from shape to shape to find similarities and variations. In a successful design, the viewer senses a plan and responds to the arrangement of shapes and colors every bit as much as to recognizable objects or to the picture's narrative content.

An enormous amount has been written about composition by great artists and thinkers who have recorded their concepts in depth. But artists rarely learn theory just by reading about it, without picking up a pencil or brush. Too much theory without rolling up your sleeves and getting into the paint is counterproductive. That said, I've concentrated this chapter on the major topics that are particularly useful to landscape painters: basic design principles; color and value; perspective and depth; and a concluding summary of overall tips to help you create stronger, more compelling images.

Detail
Tehama Haze
Pastel, page 141.

Basic Design Principles

Composition is the organization of positive shapes, negative shapes, and how they relate within a format. Beginners tend to accentuate the positive shapes, and forget the rest. Instead, one of the easiest and most productive steps a student can take to improve composition is to pay more attention to negative shapes and formats. The relationship between positive and negative shapes, often called figure/ground interdependence, is the key. Also, shapes are not isolated, but work together in the context of a format. So let's review those principles first, and then discuss other important design basics: similarity grouping, interpenetration, simultaneous contrast, continuation and closure, emphasis, edges, focal point, balance, and movement.

Format

The arena in which all design activity takes place is its format. Everything in a drawing, pastel, or oil painting occurs in a specific location that relates to the boundaries of the format. For example, a mountain placed in the center of a painting is equidistant from the edges of the format. Saw off one side of the canvas, and the mountain is no longer centered. When you pick up your sketchbook to draw a landscape, you gain a greater feel for design if you make your drawing inside a predetermined format.

When you are painting, the format refers to both shape and size of your canvas. Shape greatly determines the character of a composition. Square is very neutral, and all movement is supplied by the image itself. Broad horizontals (common in landscape) or tall verticals also direct the way in which you compose, but it's what you put inside the format that really counts.

Using a viewfinder helps you decide on format and the boundaries of a scene. I know I've already urged using a viewfinder, but it bears repeating. One of the difficulties with landscape is that boundaries are not obviously apparent. Deciding how much to include, and where to crop, is a big decision confronting landscape artists with every composition they create.

Once I had a student who wandered around a glorious painting site, unable to decide where to set up her easel. The other painters had enthusiastically started to work, but she was moping around saying, "There's absolutely nothing to paint." I soon understood her problem. There was too much to paint. I gave her a viewfinder and showed her how to use it.

This is a simple line drawing within a square format.

The shaded area represents the negative spaces of the sky. Even the small shapes between the trees at top and bottom are important negative spaces.

Like a jigsaw puzzle, each shape is necessary, whether it represents an object or its background.
As you work on a painting or drawing, try to make each shape interesting, regardless of what it represents.

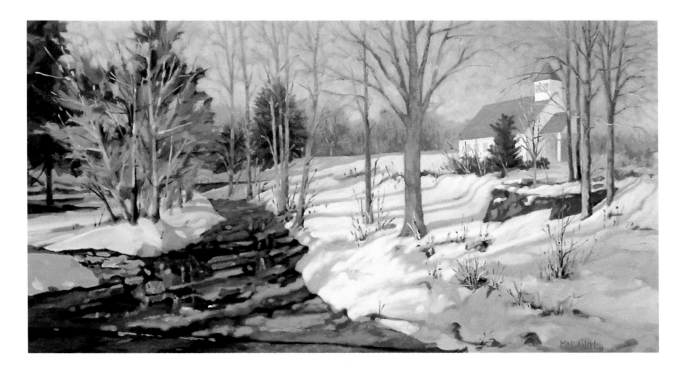

The Flooded Roadway (Church on a Hill)
Oil on canvas, 15 x 27" (38 x 69 cm), 1996. Courtesy of Schaff Gallery, Cincinnati.

The church has great emotional and visual weight, yet I chose to establish the focal point—with the most detail and the greatest contrast—in the flooded dirt road. Look at the painting upside down to see how much emphasis the road has. It is the dialogue between the church, the road, and the trees on the left that creates movement. The curve in the road and the shadows on the snow act as pathways for the eye to travel back and forth between the church and the active foreground.

Height and width relate directly to the edge of your format. The main consideration is to create an interesting division of space, which usually means an unequal division. You've probably heard the advice, "Don't divide your composition in half" (I might add that equal thirds is not much better), the reason being that if you place your horizon line, for example, directly at the midpoint—the top half of the picture representing sky, the bottom half ocean—you'll set up such equilibrium that neither sky nor sea will be the dominant shape. The attention is rigidly divided, causing boredom for the viewer.

Likewise on the vertical axis, it is rarely well advised to draw that phone pole right down the center of the picture. The negative spaces on the right and left will be too equal, the balance too static, and the eye will fall asleep. With no dominant side, the image is split in half and becomes two independent paintings, each struggling for, but not attaining, control.

Many methods have been devised for placing the focal point artistically. Forget rules. The only thing you want to do is divide the canvas in an interesting manner, which normally means placing the focal point anywhere that is a different distance from each edge of the canvas. Some painters find it helpful to put a temporary dot at the very center so they know which area to avoid as they block in the composition.

A good painting generally has a single focal point, though submotifs are often included for added interest. To direct attention to the center of interest, use emphasis, employing techniques discussed above: Include your highest value contrasts, purest color, and sharpest edges. The pull to any one area is increased when contrasts are seen against areas that have been deemphasized. It may sound simplistic, but understatement is a great tool. In order to attract less attention to an area, minimize value contrast, mute color, and use soft or indistinct shapes. There will be times

when you need to exaggerate in order to create the right degree of emphasis. That's what design is all about. Increase contrast near the center of interest, minimize contrast where you don't need it.

Visit museums to study fine paintings. Examine them with composition in mind and discover the great variety of choices used for locating focal points. Some may be high, low, to the left or right, sometimes the "pull" is insistent, sometimes subtle; but well-planned paintings, pastels, and drawings always present an interesting assortment of abstract shapes that circulate throughout each composition.

Although seeing original work is far better than looking at art in books (in fact, it's a different experience entirely), you can still learn from reproductions. If, for example, you can find a picture of *The Conversion of Saint Paul* by Caravaggio (1573–1610), you will notice at once the strong contrasts in value. It is a brilliant example of how the viewer's eye is directed around the painting by carefully placed areas of tonal contrast.

Balance

Pictorial balance must respect the integrity of the format, which in most landscapes is a rectangle. Whether internal shapes echo the vertical and horizontal borders of the format, or struggle against them, every compositional element depends upon its relationship to the format.

Visual weight, which is largely determined by emphasis, is the component you can manipulate to achieve pictorial balance.

A good asymmetrical composition seems balanced without being static, and the fun lies in placing one element within the design and balancing it with a different element to maintain a sense of equilibrium.

Visual balance depends upon the attention any area commands (the emphasis of contrast) and upon its *placement* within the picture: weight and position. The weight of size, color, value, or uniqueness of shape can be counterbalanced by the weight of position.

Similarly in drawing, you can balance a big tractor and a small lawnmower merely by placing each in the appropriate spot. There are many ways to offset elements of weight, such as: A large area of muted color can be offset by a small form of brighter color; a small, irregular shape will attract enough visual attention to balance a much larger form with a simpler shape; and deep space carries sufficient weight to offset a large object. Note how the vista on the right panel of *Chickadees* (page 142) is able to counteract the mass of trees in the other two panels.

Movement

Weight and balance lead us to a discussion of movement. This is a wonderful paradox, since paintings have no moving parts. All movement must be supplied by the motion of the viewer's eyes when looking at

Illustration by Bruce Ackerman.

Generally, the farther an object is from the center, the more weight it develops. Think in terms of a seesaw with a big bear on one end and a little bear on the other. At left, the big bear has more weight (visual as well as physical) and pulls his side lower to the ground, creating an imbalance. But, at right, if the little bear moves out to the very end of his seat and his big friend moves more toward the center, equilibrium is achieved even with bear components of unequal weight. Their placement restores balance.

The normal pattern in which we scan images on a rectangular format is from upper left to lower right.

Turning the viewer's attention from one area to another can be accomplished through the use of directional cues.

artwork. The best pictures keep eyes moving throughout the design, always delighting in relationships, making comparisons, and sensing proportional balance.

Lines and narrow linear shapes provide direction within the format. They also imply degrees of motion. *Horizontal lines* are the most passive and stable, suggesting water at rest or unadorned land stretching out to the horizon. *Vertical lines* are more dynamic, yet still are stable. They echo (as do horizontals) the geometry of the rectangular format. Think of buildings and posts and the upright growth of trees as strong but stable verticals.

Diagonal lines are the most dynamic and energetic of all, implying movement between upright and prone. Diagonal shapes are active, requiring equal opposing force for stability. A telephone pole is stable when erect (vertical), dynamic and unstable when falling (diagonal), then once again stable when it completes its fall and lies on the ground (horizontal).

Also of interest is an *implied diagonal.* Even with only vertical and horizontal shapes, there can still be a diagonal thrust based on the direction the eye travels. If you place a tall tree next to a short one with their tops both visible against the sky, there is diagonal movement as the eye travels from one treetop to the other. Even in a field of uniformly vertical grasses you can create an implied diagonal with two dark spots of color, placed apart, one higher than the other.

As artists, our job is to create movement, yet still provide a sense of order and continuity as we guide the viewer through a composition.

We normally view images from left to right, not only in Western culture; it also pertains where reading is from right to left or top to bottom. In order to keep the eye moving, we must interrupt this natural tendency to exit the bottom right corner and then redirect attention back into the design. Avoid placing objects of importance in any corner, and avoid lines that lead directly to corners, for the viewer's gaze will continue right out of the picture.

Artists commonly set up strong movement and then use an interruptive shape, known as a "brake," to deflect flow back into the composition. A form with any sort of weight, such as color or value, can balance a sloped angle and block momentum. Avoid lines that point too directly and obviously into the center of interest. Instead, lead the eye in the general direction and then let the attractive power of the focal point do the rest. Sometimes you need to modify the speed at which the eye travels from form to form. An interrupted line (trees punctuating a hillside) or a blurred line (shadows on a field) can act as a brake, slowing movement without halting the flow altogether.

Linear shapes are capable of pointing movement along their length in either direction. Decide which path is best for your needs and then enhance the flow with directional cues. The strongest device is the arrow; any tapering of a shape that resembles a point will move attention in the direction of the point.

To turn the flow, try leading one line into another, as in the diagram above. This comes in handy along the edge of a streambed as it nears the canvas edge. A few well-placed weeds can point the way to a tree that points back into the scene. You should exercise restraint with such devices, but used sparingly, they can be of service.

Color and Value

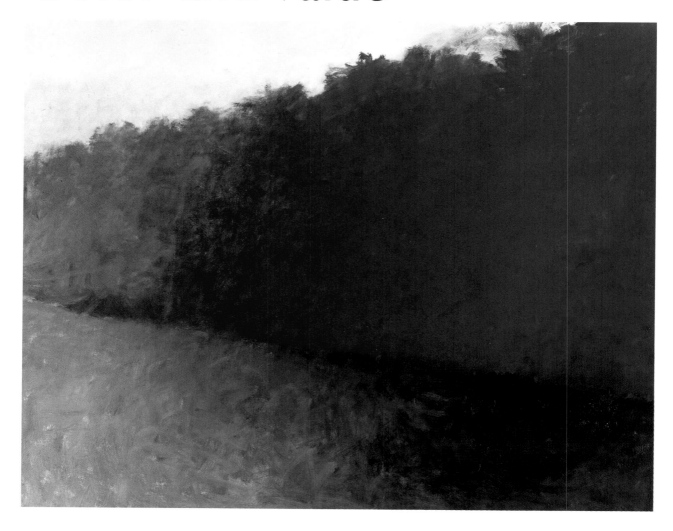

Wolf Kahn
Blue Tree Row
Oil on canvas, 42 x 53" (107 x 135 cm), 1987.
Private collection.

Simple—yet luminous.

One of the most appealing aspects of art is color. It speaks to us on a visceral level, touching our emotions on a very basic, nonintellectual plane. But color can be analytically discussed, and when the fruit of that examination is combined with an artist's intuition, the aesthetic effects of color are enhanced. To help that examination, we'll review color terminology, the value of value, the color wheel, field proportion, expressive color, and overall tips on using color.

Color Terminology

For a clear understanding of color, artists should be thoroughly familiar with its standard terminology. Every color can be described in terms of three physical properties: hue, value, and chroma.

Hue is a color's name: A leaf is green; green is the hue of that leaf. Any hue can be changed by mixing it with another hue. To cite one example, when yellow paint is mixed with blue paint, the result is green paint—a changed hue.

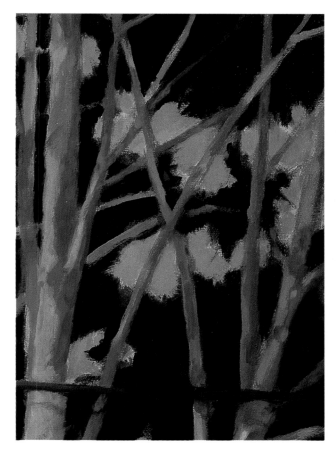

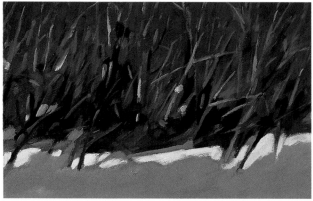

This detail (actual size, seven inches wide) of small branches at the top of the canvas is perhaps eight feet up a wall when the painting is hung, so the branches are seldom seen up close. I therefore added some specks of bright red to give life to that section—and a little treat for the eyes once they've climbed that high into the trees.

The change of value and temperature from white to light blue in the top detail (actual size, seven inches wide) gives a strong sensation of sunlight and shadow. The area was painted in stages—darkest rock colors first, then increasingly lighter colors, wet-in-wet. The lightest paint was applied last as both of above details show.

• Determine what the picture is about. Giving it a tentative title will help focus your eye on composition. If you call it "Red barn by water tank with orange maple trees near two boys fishing in pond as farmer looks on from tractor," you may need to do some editing. Perhaps you should do three paintings at this site.

• When laying out a composition, first make adjustments intuitively, then test your intuition by analysis. Cover up or block out some shapes to see if they are necessary.

• Avoid placing foreground up to your feet; rather, begin it at the point where you can look out at the whole scene without moving your head. Corot said,

"Begin your foreground fifteen meters [about fifty feet] away."

• A good way to judge shapes in composing is to look to the side of them. Peripheral vision helps judge shapes simply and accurately.

• Whenever you make a change, think why you are doing so and how it will affect the rest of the composition.

• Plan ahead. Composition should be completely established before you touch paint to your canvas. You will adjust as you go along, but have a solid idea how your big spaces are divided up; then pick up your brush and go to it.

Observing Nature

Regardless of style or aesthetic viewpoint, whether abstract or realistic, good landscape art is first and foremost about creative expression. As you select and compose, a multitude of scenic riches filter through your heart and creative soul to be transformed into a work of art infused with your personality. But landscape art also demands a deep understanding of nature. A superficial association with the natural world routinely spawns trite and meaningless work.

First View of the Day
Pastel, 24 x 18" (61 x 46 cm), 1996.

One morning, I looked out my bedroom window to see what I've seen countless times—sunlight illuminating part of a tree trunk. Remember, landscape painting is concerned with the organization of shapes and the effects of light, not just an inventory of nature's objects. Those who don't observe nature with an artistic sensibility might search for a uniform "trunk color" (probably brown) and never notice the play of light against dark.

If, on the other hand, artists study nature carefully, they will come to understand the strengths and subtleties of the landscape. And they will then be more able to convey nature's magnitude to the viewer—with conviction.

A landscape artist's skill is in large measure dependent on power of observation. In depicting nature, the answers to most dilemmas we face are right there before us, if only we can develop our ability to see them, and then to use them effectively in our work. How we employ this knowledge is a matter of personal temperament or style. But throughout history, the best painters of landscape were also dedicated and passionate observers of nature.

This chapter is not about "how to paint" skies, trees, water, etc. Instead, what follows are comments about each of these aspects of nature, and others, with the purpose of improving your observation skills and helping you discover ways to utilize such information in your landscape drawings, pastels, and paintings.

Light and Shadow

An artist's tools are limited. No medium, whether pencil, charcoal, pen, pastel, or paint, has the intrinsic ability to reproduce nature's effects of light and shadow falling upon a landscape. We must therefore manipulate our tools to create such *illusions* of light and shadow. We do this through contrast of values and through the interaction of colors.

Every object absorbs some, and reflects some, of the color spectrum. It is the ratio between what is absorbed and what is reflected back to the eye that determines the "local color" of each object. Local color refers to the surface color of a form, seen under even illumination, with no variation from the light or atmosphere. But in painting, especially landscape, it is the play of light upon the form that gives it poetic meaning.

Light Temperature and Color

There are three sources of light in nature: (A) direct sunlight, which is warm; (B) reflected light from the sky, which is cool; and (C) reflected light from nearby objects, whose light can be either warm or cool, depending upon the local color of the reflecting object. Painters prize north light in the studio for its constant, cool, uniform illumination. But outdoors, the different temperatures of direct sunshine and reflected skyshine are useful tools for portraying a sense of light in the landscape.

The color of light (and consequently its temperature) changes throughout the day and can alter the character of a scene drastically. It can even make the difference between a paintable motif and one not worthy of the effort. At midday, with the sun high, light is at its greatest intensity, a sort of warm, yellow white. The earth's atmosphere is approximately twelve miles thick if you are measuring straight up, perpendicular to the ground. Beyond that, virtually all is black space. In other words, when the sun is directly overhead at midday, its rays will shine through the blackness of space and then must penetrate twelve miles of the earth's atmosphere before reaching and shining on that oak tree over there to your left.

When the sun is low in the sky, early morning or late afternoon, its rays strike the landscape at an oblique angle, passing through more of the atmosphere at a tangent to the surface of the earth. These rays of dawn and dusk now pass through about three hundred miles of atmospheric "dust." Fewer of the short wavelengths (cool colors) are able to penetrate the atmosphere at this low angle, since a proportionately larger amount of minute dust particles are encountered. The longer wavelengths (warm colors) have an easier time shining through so the light we see appears to be warmer in color.

The result is that the color of sunlight gets warmer as the sun begins to set. This late-afternoon light affects everything it touches. The walls of a white house will appear orange or pink, and notice too that green foliage is also bathed in warm light. Since red is the complement of green, any redness in the light will have a dulling effect on the green. It may still seem bright, since it is illuminated rather than shaded, but leaves will have a slight coppery cast, more of an olive green than when they were lit by noonday sun. Likewise, the low angle of the rising sun also creates warm light.

Local color is inadequate for describing the effects of light falling upon an object. The actual surface color of a form, unaffected by direct light or reflected color, has no power to express atmosphere or lighting conditions. We are more successful in portraying the visual world if we focus on painting the color of forms as they are modified by the effects of light and shade. The presence (or absence) of direct light upon an object is as important in landscape painting as the object itself. Light is everything. Some students paint as if every day were overcast: all local color and no sense of light. The rocks are a uniform gray, the water is solid blue, the barn is flat red. Try to paint light. Don't isolate objects to paint them; otherwise, you'll begin to

paint what you *assume* each object should be and you'll stop seeing.

When examining the color of any form in the landscape, ask yourself, What kind of light is falling on this form—sunlight, or skylight? If neither, then the form must be in shadow. But if in shadow, is it modified by color that is bouncing off something else?

Reflected Light

The light that bounces into your shadows from surrounding objects does not require a shiny surface to show its effects. If you wear a yellow wool sweater, yellow light will bounce up from the sweater and illuminate the underside of your chin. In nature, the examples are abundant. The warm green of grass will reflect color along the sides of rocks and buildings. Sunlight shining on a red barn will throw barn color onto the side of a nearby tree.

Reflected color is never as bright as a highlight or as dark as a shadow. The amount of color reflected off an object is controlled by the strength of the light source, the reflective shine of the surface, and the intensity of the object's local color. That is, more color will bounce off your polished hot-pink Cadillac on a sunny day than my dusty truck under a cloudy sky.

Highlights

Highlights are seldom spots of white. A small portion of a surface reflects the most brilliant light, but the spot of intense light is bordered by areas that become less brilliant as they catch light at slightly different angles. I've heard this called "the gradation toward the light," and it helps make a highlight believable.

On a highly polished surface, the core of the highlight may appear white, but what about objects without gloss? How do you paint a highlight on a red rose, for example? Do you add a bit of white to brighten the paint? No, that makes the paint lighter, toward pink, but not brighter. Yellow? That would change the hue, toward orange.

The answer is pure red. It's simple. When you first begin to paint the rose, dull the red paint ever so slightly (using a microscopic amount of green works nicely). The red will still look very red even though its chroma has been lowered. But now, when you paint a highlight on the edge of a rose petal with the pure red, it will really sparkle. The best way to show brightness is to show it near something less bright.

Direction of Light

An artist's vantage point controls far more than perspective. In relation to the sun, it can transform the image completely. Observe any scene and note how much it changes depending upon the position of the sun. Try painting under all of the varying angles of light.

Backlighting, light behind the subject, is the most dramatic condition. With it, masses are simplified and details are minimized. There is considerable shade but not much color. The key is simplicity, with few distracting details.

Flat lighting, light behind the artist, illuminates everything and shows lots of detail. Colors are strong without much shadow.

Side lighting, light coming from the left or right, also includes the raking light of early morning and late day. Notable characteristics are strong modeling of form with sun and shade. Side light creates descriptive shadow without eliminating color.

Many novice painters would concentrate on painting the road rather than the shadow shown in this photograph. Note how the sunlit grass and sunlit road combine to make one unified light shape, intermingling "visual shapes" and "identifiable shapes." That is, the eye combines sunlight or shadow masses while the intellect strives to identify objects such as "road" or "tree."

Shadows don't always look the same. They differ greatly, depending on the strength of the light source and nearness of the viewer to the objects concerned. But as a general rule, the intensity of a shadow decreases as it gets farther away from the object casting the shadow. And the closer an object is to the ground, the denser is its shadow.

Shadow

Shadows occur on the unlit side of an object. *Cast shadows* occur when an object interrupts the path of light.

The depth of a shadow and the amount of color it contains are determined by three factors:

• The proximity of the objects that cast and receive the shadow. That is, the closer they are to each other, the less chance any reflected light can modify or lighten the shadow.

• The strength of the light source. The brighter the day, the deeper the shadows; there is more contrast between light and shade when the sun shines brightly.

• The nearness of the shadow to the viewer. A barn's shadow that falls near our feet will seem deeper and darker than the shadow of a similar barn in the distance, for the effect of atmospheric perspective will lessen both the depth of the shadow and the brightness of any nearby sunlit areas. The distant shadows will exhibit less color and less detail as well.

Shadows are transparent, not solid. Paint them thin and remember the modifying effects of reflected light. Black shadows only work with night paintings, when the moon and stars provide the illumination.

You can paint shadows a bit too cool at first, then introduce some modifying warm colors (from adjacent areas) while the paint is still wet. Most cast shadows show tinges of a hue that is complementary to the light source, though never at full intensity.

As to the act of painting complementary colors in shadows: If you look at one color long enough, you'll crave seeing its complement. If an object in the light displays a strong color, the adjacent shadow will appear to contain the complement, but be careful not to overdo it if your aim is a naturalistic painting.

Judge your shadows while looking into light areas. If you look too closely into shadows, your eyes will adjust to the dim light (your pupils will dilate) and you'll begin to see more and more detail. Putting too much detail in shadows will diminish the impact of light falling upon the illuminated portions of the scene. Suggest the detail, show some variety in the dark masses, but keep it all subordinate to areas of light.

New Year's Morning
Oil on panel, 15 × 27"
(38 × 69 cm), 1991.
Collection of Gene and
Barbara Barrie.

The shadows and their interaction with the sunlit snow are crucial. The effects of light are far more important than the trees themselves.

In this photograph, the blacktop road in sunlight appears to be about the same value as the white paint in shade. White and black objects the same value?! Yes, when you look beyond local color. Light objects in shadow are not as light as you might think; darks lit by the sun are not as dark as they are often painted. Of course, dark and light objects seen under the same illumination will still read as dark and light objects, regardless of the strength of light.

Shadows are often modified in color and lightened in value due to reflected light from nearby objects. But never should they be painted as light as the sunlit portion of the composition. They are, after all, still shadows.

A shadow need not be painted as merely a darker version of an object's local color. Keep color in shadows instead of making them dull, dark, and murky.

You can't use the same color to represent both light and shade in a single object. However, it often promotes unity in a composition if you use the colors elsewhere in the painting in a different capacity.

Shadows can provide information about objects that are not in the picture plane, and can increase the viewer's understanding of contour and texture as well. Trees, hills, buildings, or clouds can cast shadows in convenient places; it's within your power to create an intriguing sense of place with mysterious shadows.

Keep detail and value contrasts to a minimum in shaded passages. The best sense of luminosity in a shadow comes from the proper use of dark accents within it (keep darkest accents in the foreground). The only deep darks are to be found in such accents. However, be careful to retain the tonal integrity of the shadow. If there is too much variety, the passage will look spotty.

Under most conditions, the shaded side of a white house will be darker than the sky. Even though the building is painted white, the unlit side will appear dark by comparison. Observe the effects of light, not just the local color. We must not paint an *object* so

much as paint what light *does* to that object.

Variations in a sunlit area should all be sunlit; variations in shadow should remain in shadow. This will maintain the essential character of light and dark passages.

Though said earlier, it bears repeating: You need light to show dark—you need dark to show light. A dark shape will look its darkest when painted next to an area of light value, and vice versa.

If your paintings seem to lack light, the reason might be that they lack those dark passages so necessary to show the light. Don't be timid about contrast.

To create the effect of full, strong sunlight, strategically place lights and darks throughout your composition and play them against each other. Train yourself to see the light patterns and the value patterns.

Morning Light

Several years ago, fascinated with the effects of early morning light, I began painting at dawn, driving to a preselected painting spot while it was still dark, and setting up my easel with the aid of my truck's headlights. With hot coffee from my thermos, I was able to relax by the easel and wait, brushes or pastels ready as I peered into the predawn landscape.

As my eyes adjusted to the dim light, simple shapes became apparent. I would block them in with muted colors. I could perceive only the simplest of scenes, a few black shapes on a field of gray, but as dawn approached and the sky began to lighten, black shapes slowly turned into trees and cliffs. It was like watching

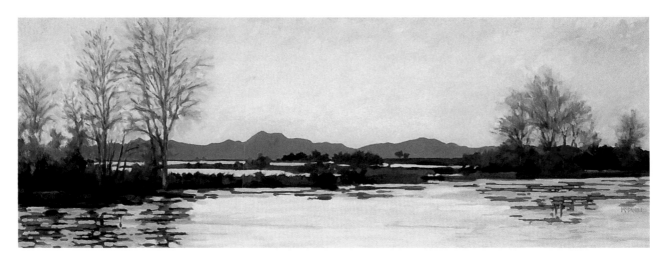

Sutter Buttes at Dawn
Oil on panel, 9 x 24"
(23 x 61 cm), 1995.

In the morning, the water was still and the scene was backlit.
The distant mountains were simplified to a flat silhouette.

a Polaroid picture develop. Blackness turns to color as vagueness is gradually replaced by clarity.

If you have trouble simplifying, watching the sunrise will be very instructive. Nature follows the artist's sequence, arranging basic large shapes first, adding a little definition, then more while intensifying colors, and finally adding highlights as the scene becomes bathed in sunlight.

A disadvantage to painting at dawn is that as emerging sunlight shows us more and more of the countryside, the tendency is to add too much detail. Be careful not to overstate the image as your painting nears completion. Once the sun rises, every time you look out at the landscape, you see three newly articulated shapes, and a bit of the early-morning mystery is lost. You must strive to maintain your initial vision.

Late Afternoon Light

Some of the best painting light occurs in late afternoon, and in summer, visibility is good until eight or nine o'clock, when painting light is superb. Lengthening shadows and warm colors from the westering sun create a multitude of dramatic effects just right for landscape art. Unlike the morning, when you paint in late afternoon less detail is visible. The light will even-

Ocean Walk Before Breakfast
Oil on canvas, 32 x 48" (81 x 122 cm), 1977.

There was so much moisture in the early morning air that forms were barely visible. All shapes were bathed in a soft, ethereal light until the sun burned off the coastal haze.

tually fail, but before it does, you will observe the poetry of twilight.

The light of early morning or late afternoon, though warmer, is not as brilliant as that of midday. Contrast isn't always as pronounced as one would think.

Twilight and Nighttime

Diminishing light neutralizes color and value contrast. Yellow becomes gray ochre, bright red turns the color of dull brick. With nightfall, the landscape becomes deep blue and black. Any light at all, from setting sun, moon, or stars will look all the brighter by comparison. Trees in moonlight lose detail and become mere silhouettes.

Light on Angled Surfaces

The distinguished teacher, author, and painter John Carlson (1874–1945) conceived a Theory of Angles, in which he laid out "four prime planes of the landscape," a concept that provides a simplified means for understanding light as it falls on a scene before us.

Essentially, the value of a plane is as dependent on its degree of angle to the light source, the sky, as it is on its local color. By creating distinct planes of light, a landscape painter can emphasize important elements of a scene while eliminating nonessentials. The four planes are:

In this illustration of planes in a landscape, the figure shows a flat plane, slanting plane, and upright plane. Notice how the dark stripe also conforms to the variations of angle.

• Light Source (sky): Normally the lightest value in a painting is sky. When stormy, it is still lighter than the ground, for less light falls to earth if it cannot penetrate storm clouds. Snow is the exception, often being lighter than sky.

• Flat Plane (ground): Horizontal surfaces receive more light than other forms. Variations in local color are still evident but are all relatively light when compared to the same colors on slanting or upright planes.

• Slanting Plane (hills): This plane presents an oblique surface to the sky, so it receives less light. Its value is lower than that of the flat plane.

• The Upright Plane (trees): Vertical planes are of darkest value, as they receive the least amount of light from the sky.

An exception to the above four rules is if the sun is low, a vertical form will receive more light than usual and a horizontal surface less than usual.

Carlson's Theory of Angles helps us to see and to simplify the effects of light so that we may concentrate on how an object is lit rather than its local color, the surface detail, or even what the object is. With this theory in mind, the artist can look at the landscape and organize its large masses simply and quickly.

Weather

You will limit yourself if you develop too great a fondness for one particular kind of day. Although a clear, sunlit day does provide the most vivid interplay of light and shade, the ethereal beauty of a foggy day or the raw power of a storm can be admired as well.

Overcast Skies

Clouds diffuse sunlight. No matter how dark the sky may be, it still lights a scene. It functions as an overhead blanket of illumination so that cast shadows and reflected light are greatly diminished, if visible at all. The value range is limited, especially as forms recede into the hazy distance, unified under soft silvery light.

On a gray day, lights and mid-tones cluster together and darks stand out visibly; darks are therefore the best accents. By comparison, on a sunny day, darks and mid-tones cluster together and lights stand out.

Fog is moisture-laden. Mist disperses light so it seems to bounce all over the place, illuminating objects from all directions. This scattered light flattens masses and destroys shadows. The result is a softened unity of tone with a narrow range of values. Colors

are also cooler than on sunny days. Keep value and temperature contrast to a minimum. Fog helps us see simple shapes rather than details.

A slight haze is great. Summer in Woodstock, or the entire Eastern Seaboard, for that matter, has a number of humid days that cloak the landscape with a form-softening mist. Details are less apparent through the haze, and the scene undergoes a natural simplification. A clear day, on the other hand, can look very sharp, with crisp edges and high contrast.

The Four Seasons

Spring is noted for its constantly changing weather patterns. Spring showers, a drying sun, then more showers can play havoc with a slow and deliberate painter, but the interested observer will find considerable variety in lighting effects. Spring buds are fresh and light. They show up best when lit by the sun while seen against a muted dark background. The time of inflorescence is a welcome addition of soft warm color that heralds the coming warm weather. Each spring, some of the new shoots have a decidedly

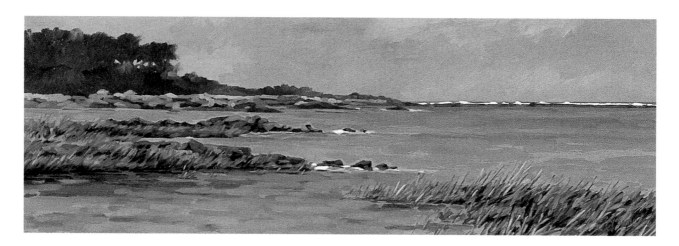

November Chill, Coastal Outlook
Oil on panel, 6 x 16" (16 x 41 cm), 1992.
Courtesy of John Pence Gallery,
San Francisco.

The white surf keeps this small painting from seeming dark and gloomy. A small speck of high value in a dark painting completes the value range. Note how warmth in the left side of the sky helps integrate the sky with beach and foreground grasses.

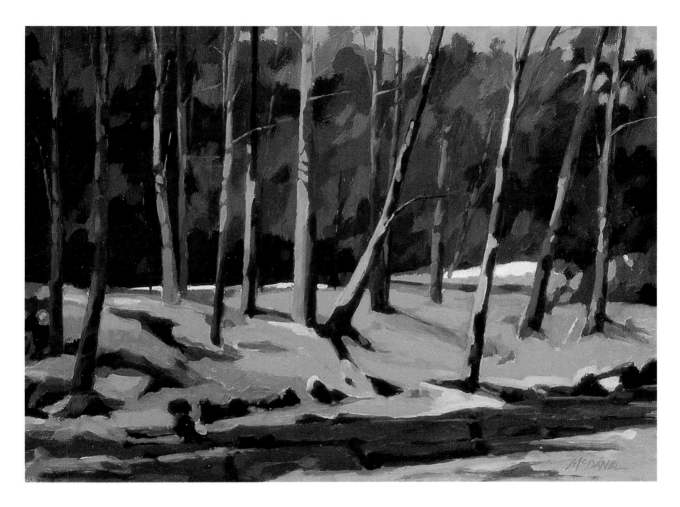

colorful cast. Red maple puts out scarlet shoots that resonate when lit by the sun. Willow puts forth yellow shoots and are among the first trees to come to leaf.

Summer is a time of mature leaves, and you must look intently at greens to find sufficient variety. Inexperienced painters who are overcome by the abundance of summer leaves tend to paint symbolically, without studying the light. Their trees look artificial and monotonous. To avoid this, accentuate subtle differences in hue, value, and especially chroma. Discover how much red there is in various masses of green.

Autumn color resonates on a cloudy day. The gray sky attenuates the color in a pleasing way, whereas a clear sunny sky provides harsh contrasts of color. Autumn paintings in full sunlight usually look phony. Beware of being led astray too easily by the exhilarating brightness of the leaves; soon all subtleties of tone are

Riparian Winter Study
Oil on panel, 9 x 12" (23 x 31 cm), 1992.

This is an alla prima study that I later expanded into a larger painting. Although there was snow on the ground, the sun was out and there was no wind, and I was pleasantly warm in my winter boots and down parka.

forgotten. Try including some evergreens or open spaces in the composition for variety, and let the red, orange, and yellow leaves serve as accents.

Winter is a great time for landscape artists. Snow may be a nuisance for commuters but it's a real friend to nature painters. It can rival the sky for brightness, and will reflect an array of colors. Winter skies are often very dramatic, and the leafless branches are far from colorless. The light of winter is clear and clean; winter colors may be muted, but they are not drab.

Rocks and Mountains

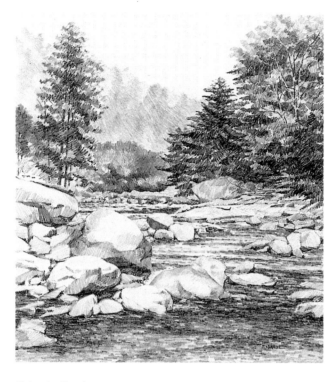

Calamity Brook
Pencil on museum board, 10 x 8" (25 x 20 cm), 1993.

At this point, high in the Adirondacks, you can walk across the Hudson River without getting your feet wet. The rivulet is strewn with rocks and boulders.

Rocks aren't all the same, so don't paint them that way. Look for variety in size, shape, and color. Note that not all rocks sit on top of the ground; many are just poking through, with much of their bulk hidden beneath the surface.

Is the character of the rocks you see sharp and angular or worn smooth? Depict main facets, cleavage, and weight. Draw or paint rocks as a solid mass illuminated by a particular light source. Look for major planes and indicate light, middle, and dark values simply. If it's rugged, paint it rugged. Try using a palette knife. Rocks and hills are convex; enhance that quality with the direction of your strokes.

At the horizon, mountains form an important angle against the sky. Use them as abstract directional shapes for creating structure in a landscape. By adjusting value contrast between mountain and sky, you can call a greater or lesser amount of attention to their meeting. This affects the pace of the image, or how fast the eye travels across the canvas.

Being distant forms, mountains are automatically simplified to a degree. When you paint them, concentrate on what you see with your peripheral vision as you look at the foreground or middle distance. To accentuate a dark passage in the foreground, lighten the value of the background mountain adjacent to it.

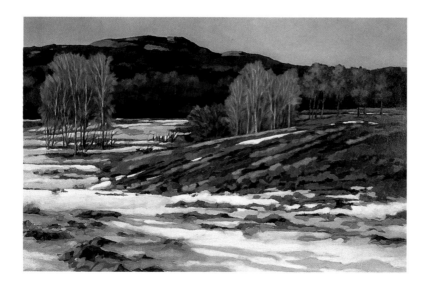

Westering Sun
Oil on panel, 14 x 20" (36 x 51 cm), 1991.

The strong side lighting, typical of later day, emphasizes the contours of the hill.

Trees

"I see in nature, for example in trees, expression and, as it were, a soul."
—Vincent van Gogh

It is important for artists to develop empathy for their subjects. With trees, it's quite easy—they are so symbolic of nature's cycles: youth, maturity, old age, and death. We identify with trees. Their upright stance invites comparison to the human form.

There are nearly nine hundred tree species in the United States alone. Just like people, they all have distinguishing shapes and features. As with drawing the human figure, we must first understand the basic anatomy of trees before rendering extensive details. Learn to draw and paint the winter skeleton of a tree and you will be better able to paint it in summer with its full complement of foliage.

Observing Tree Growth

Draw trees in your sketchbook. Learn how they grow and how light plays on their surface. Sketch their "pose." Do they stand straight? Lean? Twist? Observe their framework and roseate haze in late winter; how buds appear, enlarge, and leaf out in spring; how translucent, dust-free spring leaves exhibit more yellow-green than their mature counterparts in summer.

Notice the rhythm of growth as each tree balances itself. Yet they are communal, sharing the same space in a binary fashion, pairs crowded together, each stretching out its branches to the sunlight on opposite sides. If you cut down one of two neighbors, the remaining tree will look imbalanced.

Depicting Foliage

How do you represent a tree made up of thousands of leaves without losing the strong shape of the entire tree? Suggest only a few leaf forms and imply many more. Paint some sunlit leaves contrasted against a dark tree cavity, or a few dark leaf shapes visible against the sky. The use of a partially loaded brush can drag a hint of paint across the canvas, suggesting hun-

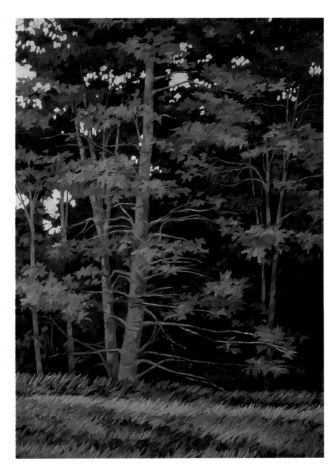

Late Afternoon
Oil on panel, 36 x 24" (91 x 41 cm), 1988.
Private collection.

Who says the sky is blue?

dreds of leaves with each stroke. Describe some foliage with a soft edge, especially to indicate the far side of a tree, to keep your image from looking like a two-dimensional cardboard cutout.

Examine contrast and exaggerate if it helps to clarify forms, but not only by using brighter color—sometimes it means using more muted color. If you've

overloaded your composition with a mass of summer greens, the painting will be tedious. Too much summer green cries out for visual relief. Use neutrals and supply some reds or warm browns. Study works of Corot or Daubigny and you'll see that a great many of the leaves are hardly green at all, yet with a few well-placed accents of more intense color, foliage masses in their paintings appear green.

"Sky Holes"

Paint trees by looking at their shapes against the sky. Be sure to paint some "sky holes" in the foliage for the birds to fly through. They should be a bit darker, cooler, and duller than the surrounding open sky. The smaller the hole, the more pronounced the effect. If sky holes are not painted a shade darker, they will pop out at the viewer. Also, paint the foliage just a bit lighter near the sky hole. Be subtle, though.

Sky holes are often larger at lower parts of a tree, since branches closer to the ground are heavier and farther apart. Branches balance a tree. If the trunk leans to the right, one or more branches will lean out noticeably to the left for stability. Create visually appealing negative spaces with sky holes and avoid monotonous parallel branches.

Tree Trunks

If you look at a tree trunk and automatically reach for burnt umber, look again. Even if umber approximates the local color of the trunk, observe the effects of light and shadow. Dusk and dawn especially modify the local color of bark. Add to this the color of moss or lichen, as well as reflected light from nearby objects, and you have quite a range of palette possibilities—tints of pink, green, yellow, even blue.

A telephone pole comes straight up out of the ground, but not a tree. A tree swells up out of the ground, with a slight broadening of its base where it meets the soil. And don't forget the roots.

The trunk of a fast-growing tree, such as a white pine, tends to develop a straight spine, with thin lateral branches. A slower-growing oak, on the other hand, will usually develop a meandering trunk with many heavy, graceful branches.

Note where the first branches extend out from the trunk. A maple trunk is shorter by comparison than that of an elm. Observe shadows on the trunk and how they change as the day progresses and how they curve as they fall across the trunk. These curves become more pronounced the higher up the trunk they climb, for they are actually ellipses far above our eye level.

Stumps and broken branches are paintworthy, too. The old dead hulks that line a swamp or beaver pond are full of personality, as is the rough texture of hickory bark, which can be a subject in itself.

Diffraction

The value of tree branches is influenced by the amount of light that wraps around their edges. Known as *diffraction,* this principle states that light bends slightly as it passes by the edge of an opaque object. When leafless branches are seen against the sky, they have so little bulk that diffracted light makes them appear lighter in value. The narrower the branch, the lighter its value. To suggest the effect of a luminous sky lighting small branches, paint them lighter as they become thinner.

Another way is the dry-brush technique. Drag a slightly lighter color over the tips of branches that have been previously painted and are now dry. You can also modify the effect by rubbing the surface with your fingers.

Proportion

Paint the gradual diminution of branches. A progressive reduction in diameter is critical in painting a lyrical tree, one with proportion, flow, and grace. Branches must turn into twigs by the time they reach the outside edge of the tree. When a branch forks into two or more smaller branches, the combined diameter of the new shoots is equal to the main branch before the split. Although branches are only seen in their entirety when free of leaves, remember that they still taper, even when completely foliated.

Relate the width (and position) of a trunk to its crown. How do the branches grow? Up? Down? Straight out sideways? Opposite each other or alternating? Hemlock branches, for example, angle upward near the top of the tree, then stick straight out at the

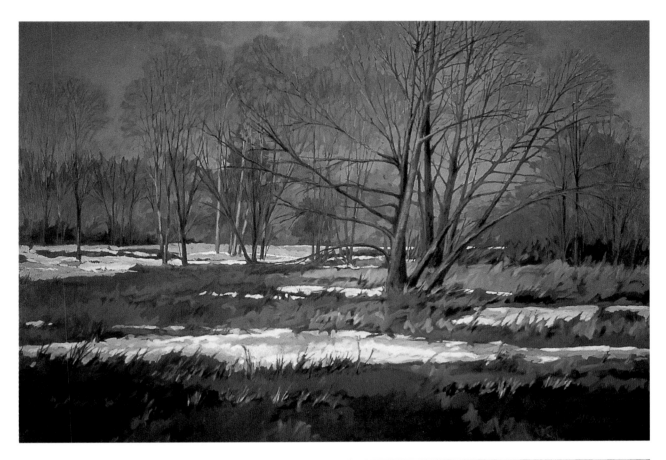

Saratoga: Spring
Oil on canvas, 30 x 44" (76 x 112 cm), 1988.

Once the snow cover begins to melt and portions of the bare earth begin to peek through, you are presented with a multitude of intriguing horizontal shapes to counterbalance the upright thrust of the leafless trees.

In this detail of the painting above, bare tree limbs are silhouetted against the sky. The glazing and scumbling of warm colors on the tree suggest the textured bark in sunlight.

middle, and droop downward near the bottom. Be sure to paint some branches angled directly toward or away from you. A tree painted completely in profile looks artificial. If a branch coming toward you angles upward, showing its shaded underside, it will usually be darker than branches receding on the other side of the trunk, presenting their sunlit planes to view.

Tree Notes by Species

Become an expert on your local trees. Learn their idiosyncrasies. A "perfect" tree doesn't make as interesting a painting as a gnarled and weather-worn oak with plenty of quirks. Here are a few characteristics to watch for:

• Sugar maple displays great autumn color, develops a wide crown when growing in an open space, and has heavy limbs and fewer, larger sky holes.

• Oak often keeps some of its leaves in cold weather, providing the painter with a convenient supply of warm, russet-colored touches to include in the winter landscape.

• White pine, with long, horizontal branches, has needles massed in boughs; its branches are lighter in weight at the top of the tree, the uppermost pointing upward. Avoid the sawtooth repetition of cartoon Christmas trees when painting conifers.

• Shortleaf pine is very tall and straight, its dark brown bark composed of irregular scaly plates that can be effectively depicted by using a palette knife.

• Birch, with light limbs and a profusion of small sky holes, must be painted with restraint to avoid corny exaggeration.

• Coconut palm is flexible, graceful, and bends with the wind.

• Lombardy poplar, tall and supple as it sways in the breeze, lends great vertical accents in a horizontal scene.

Shasta Pines
Pencil, 11 x 8" (28 x 20 cm), 1994.

This is a typical drawing from one of my sketching trips. It is more than a notation of trees; it records my impressions of the pines, shadows, and slope of the hill, and triggers my memory of the fresh pine scent.

Leaf Cluster
Pencil, 6¹/₂ x 11" (17 x 28 cm), 1996.

This is a value study as much as anything else, yet the placement of shapes within a format helps considerably in containing dark masses and in creating interesting negative shapes.

Bushes, Flowers, and Grasses

Bushes grow differently from trees in that their branches usually emerge from the ground, not from a main trunk, giving many stems nearly equal prominence. Although trees are more spectacular landscape components, bushes, flowers, and grasses all add character to a drawing or painting.

When including delicate flower forms in a landscape, I like to paint grass right up into the floral area before adding blossoms. Then I suggest the flowers with a few strokes, rather than rendering every blossom. Flowers become smaller as they recede into the distance, and spaces between them also diminish (linear perspective). Make distant flowers less brilliant than those in the foreground (atmospheric perspective). Consider your overall design and group floral masses into interesting shapes.

Don't forget weeds and vines, as well as the birds and bees.

Paul Zimmerman
Tournament of Flowers
Oil on canvas, 24 x 36" (61 x 91 cm), 1977. Courtesy of the artist.

The artist was not interested in a botanical rendering, but more concerned with the interplay of colors, as if the flowers were knights' colors at a jousting tournament.

Skies

Passing Shower
Oil on panel, 20 x 16" (51 x 41 cm), 1996.

A summer storm often provides wonderful lighting effects for an artist. Here, the sun is beginning to break through the clouds and illuminate the fields.

Skies are not flat backdrops for our paintings. They have depth and conform to the laws of perspective just like the land. You can't touch skies, though; everything else has mass and weight, but skies are light and vaporous.

As the source of light in a scene, the sky is normally the lightest area in a painting (snow being an exception). However, to direct attention to a light passage on the ground, it's best to alter adjacent values to increase contrast. So if you wish to feature a light area next to the sky, you will need to darken the sky. But if you paint the sky dark throughout the composition,

you run the risk of making a painting with no light. Instead, modulate the value of the sky, making it darker where it meets a light form and allowing it to lighten up elsewhere.

Always observe the sky when you step outside. There is infinite variety up there. Far too many beginning painters assume that skies are blue and clouds are white. But further attention to the heavens will convince you that every color on your palette can be employed for painting skies.

One of the best ways to learn to paint skies is by making numerous 8 x 10" studies, either on Masonite panels or paper prepared for your chosen medium. Paint the sky forty-five times. You'll be surprised how much you learn from this process. Include a suggestion of land at the bottom of each study or show nothing but sky. Sky effects are fleeting; you need to develop your memory and learn to work simply and rapidly. Paint many different types of sky. Morning and late-afternoon skies are dramatic, as are those moments when the sun first penetrates a haze or bursts through the trailing clouds of a passing storm. Try Naples yellow, cadmium red light, a touch of alizarin, and white for the lower half of the sky. While the canvas is still wet, touch cerulean blue to the top. As you work it around, wet-in-wet, perhaps add a very pale tint of alizarin.

There is more gradation, zenith to horizon, on a clear day than on a hazy one. On an overcast day, cloud cover acts like a lampshade, diffusing light. Oddly enough, there is greater contrast between earth and sky on a mildly overcast day. The sky is lit up from the back and therefore filled with light, but less light passes through to the ground, leaving it darker than on a sunny day.

Skies become warmer and lighter as they near the horizon, brighter and lighter as you look toward the sun, and darker as you look away. The eye cannot distinguish colors easily as they approach the light source; blue washes out to a colorless glare as it nears the sun's halo, but the sky opposite is a brilliant blue.

In this sky study in oil, I merely hinted at the landscape and concentrated mostly on the personality of the sky.

Skies can be lightened or darkened to suit the scene, and clouds can be placed wherever they are needed to add a particular value or shape. The four sky studies shown below were all executed in pastel. They are meant to illustrate the sky's infinite variety and the expressive possibilities this means for the landscape artist.

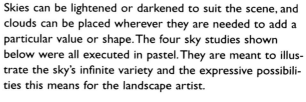

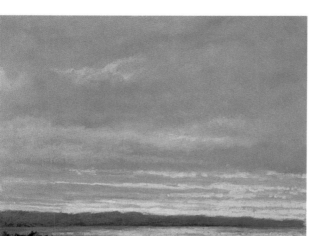

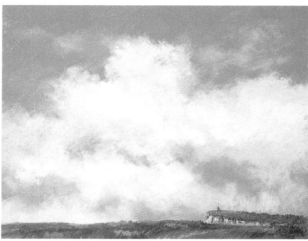

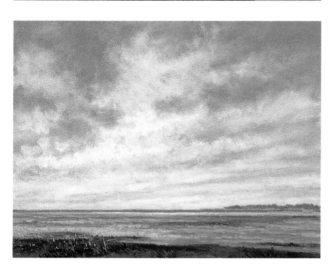

The more you look toward the sun, the more yellow you see. Move your gaze away from the sun to see more blue.

Skies set the mood for a painting but must be integrated with the image as a whole. A tradition among landscape painters is to repeat some sky color in the foreground, which helps unify a composition and averts the disruptive problem of the sky separating from the rest of the image. While I bristle at the thought of formulas, this one does promote unity.

One element must dominate. A painting should be either a *land*scape or a *sky*scape. If the scene is complex, paint the sky simply. If the sky is complex, paint the scene simply.

Clouds

Clouds aren't puffy white balls of cotton, although they often look cotton-soft. They are vaporous particles of water or ice, becoming visible when they rise into cooler heights of the sky, forming into perceptible masses of various patterns. Scientifically, clouds and their patterns divide into four categories: cirrus, cumulus, stratus, and nimbus—with many half-steps and combination forms.

Cirrus are the loftiest clouds, composed mostly of ice crystals and often nicknamed "mare's tail" clouds, due to their wispy, flowing contours. When rows of small cirrocumulus clouds form, we see a "mackerel sky," resembling a pattern of fish scales.

Cumulus are whitest and lightest near the utmost height of the sky, and are frequently evident in late afternoon floating in the eastern sky, opposite the setting sun. They are massive, mountainlike clouds with flat bases and rounded outlines.

Stratus are lazy, linear, and restful. They are simple forms with great horizontal extension, the easiest clouds to paint, and often the perfect choice.

Nimbus are low-hanging rain clouds. They exist in great variety and offer a multitude of dramatic and moody shapes. The bases of these clouds are not always clear, sometimes fusing with hilltops or indistinguishably merging with rain.

Clouds possess free movement; they may linger for hours or form and dissolve within minutes. An artist must understand them, for they won't always cooperate by posing motionless until their portrait is complete. So when you start to compose a scene, note existing cloud patterns, decide where their major shapes will be in your design, and block them in quickly, before blocking in the landscape.

If during this stage you see a particularly good example of cloud shapes, make a rapid charcoal or pastel sketch for reference.

When you are developing clouds further, there are many points to consider:

• Clouds must be depicted so that they seem to float, but they can exhibit a lot of color. To integrate clouds with the rest of a scene, use subtle versions of terrestrial colors. Reflecting land color up into the underside of clouds will also suggest luminosity.

• The "lightest light" does not occur at the edges of clouds. They are vaporous and less dense at the edges where some sky color shows through. The exception is when clouds are backlit by the sun. Then the opposite holds true, as light that is more visible shows through at the edges.

• The bases of clouds are darker than their tops, but rarely as dark as the ground. Even dark clouds are seldom darker than the earth, for they obstruct light that would otherwise fall upon the ground.

• Cloud shadows provide an excellent way to subordinate certain areas of the landscape. If a portion of the land needs to be subdued, invent cloud shadows to cut down on the illumination.

• Smaller cloud fragments are usually less bright than the mother cloud from which they are separated. Somewhat translucent, their light color merges with the darker sky blue showing through them.

• Clouds near the distant horizon, with sunlit tops and sides visible, should be painted smaller than clouds overhead. The overhead clouds should show shadowed undersides.

• Be careful not to paint all clouds the same size, shape, and value. Fresh clouds are always arriving, evolving, and departing, so you should be able to find plenty of variety.

Water

"The water continually flowed and flowed and yet it was always there; it was always the same and yet every moment it was new." —Hermann Hesse

Water has rhythm. Squint. Look for contrast and movement. Don't automatically paint water blue. Like a mirror, it is blue where it reflects blue sky, but green where it reflects a pine tree or whatever other color is visible on a riverbank. Changes in the color and/or value of foliage along the bank must be addressed in the water as well, but usually the reflected image is less intense than the original.

A placid surface with mirrorlike reflections is not too common, except for some mountain lakes on windless days. Conversely, the more ripples or waves on a body of water, the less likelihood of anything being reflected at all.

Crucial to an understanding of reflections and how to depict them is observing the "angle of incidence." A vertical or horizontal form is reflected exactly as it appears on land, but all diagonals are reversed. A tree on the riverbank that leans to the viewer's left will be reflected upside down, also leaning to the left.

Atmospheric conditions have their impact on water color and value, but even on the clearest days, water absorbs some light, making a body of water almost always darker than the sky.

Perspective applies to water as to any flat plain; the color of foreground water is darker, and details, such as ripples, are larger. Think of radiating circles on a flat plain, as from a pebble dropped in water. The circular shape will flatten to an ellipse as it moves away from

Pacific
Pastel, 18 x 18" (46 x 46 cm), 1996.

Sunlight on the water is the primary subject—simple as that.

Angle of incidence. Objects are reflected in a pond as if in a mirror, with the diagonals reversed.

you, ultimately appearing to be a flat line as it nears the horizon. The closer circles come to you, the rounder and larger they become.

As reflections come forward, they catch the rims of these ever-widening circles, resulting in greater distortions. So when you paint reflections, make them wiggle most as they advance toward you. As zigzag shapes reach the foreground, they are even larger than the original objects being reflected. Use larger brushstrokes as reflections advance, and try to indicate the rhythm of fluid water. Pulling some dark ripples across light reflections, and light across dark, will help emphasize the surface of the water.

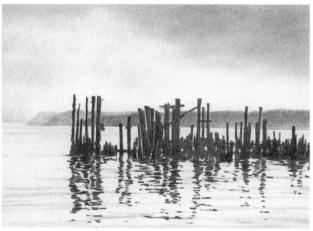

April Surge
Pastel, 12 x 22" (31 x 56 cm), 1994. Courtesy of John Pence Gallery, San Francisco.

Rushing, turbulent water does not provide clear reflections. Everything is churning, and it is the contrast between foam and open water that creates the design.

Abandoned Ferry Slip
Pencil on museum board, 8 x 10" (20 x 25 cm), 1991. Collection of Mr. and Mrs. Robert Gravinese.

These decaying timbers attracted my attention because of the fluid, abstract reflections. They repeat the verticality of the pilings, yet describe the horizontal plane of the water at the same time.

Where rocks meet water, mix hard and soft edges. Otherwise, the rocks will be reflected too perfectly, as if they are bordered by a mirror. When white water is in shadow, don't paint it stark white. Foam should be painted white only when in full sun.

It would be an oversight to exclude *seascape* from any thorough discussion of landscape painting. With its wide range of moods and colors that have fascinated painters for centuries, the sea can be serene and meditative or wild and savage.

Harbor scenes are also favorites of many artists. If you romanticize docks by cleaning up all the debris

you see there, you won't really capture the flavor of the place, so include some objects lying about, but eliminate some for the sake of simplicity.

Low tide is a good time to paint at a dock, when you can look down at the forms of boats at the pier. Simplify rigging, which is confusing if it gets overly detailed. The color of dock water is usually modified by green. Seldom will you see clear blue water in an active harbor—there is just too much debris and fuel in the water. Group seagulls artfully; they shouldn't be hurriedly dashed in at the last minute. Trite little birds have destroyed many a harbor painting or seascape.

Snow

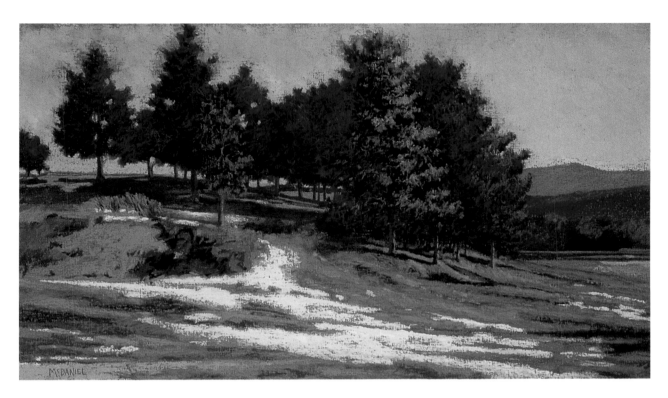

Late Winter, Late Day
Pastel, 12 x 20" (31 x 51 cm), 1990.
Courtesy of Schaff Gallery,
Cincinnati.

I particularly enjoy painting the land-
scape when much of the snow has
melted and only patches remain.
They can form such wonderful
shapes. Also, when the sun is low in
the sky, it floods the scene with
warm light that contrasts nicely with
the cold snow.

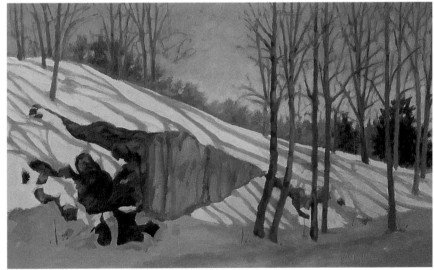

Sunlit Rock
Oil on panel, 6 x 9" (15 x 23 cm), 1993.
Shadows are useful for describing the contour of the land, suggesting variations in
the terrain. Shadows are also quite effective for directing the viewer's attention
within the composition.

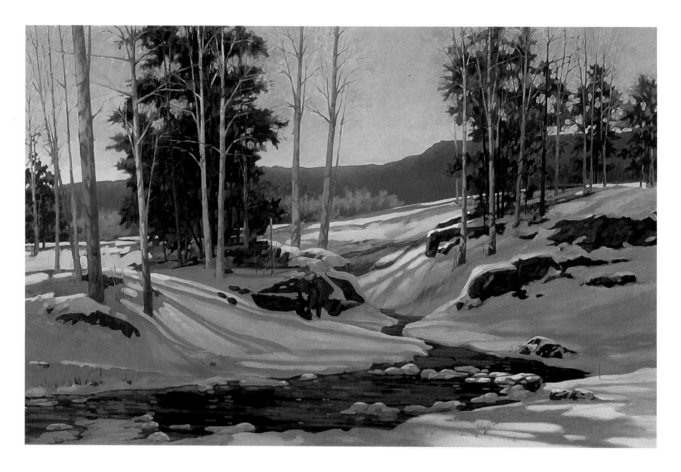

It is seldom effective to paint snow pure white. Sunlight or reflected light of the sky is usually evident in snow color. Snow also reflects colors of surrounding buildings and trees. Snow is unusual in nature in that its overall value is often *lighter* than that of the sky.

Sometimes it's too frightfully cold to stop and paint snow when you see it. But you can look at it intently, imagine how you'd paint the scene, mentally mix your colors—then use all that information later.

Observe that in early morning or late afternoon, snow takes on a rainbow of colors and vibrant shadow patterns reflecting the coolness of the sky. In startling contrast, sunlit portions of snow reflect back its warm color, sometimes prismatically enhanced by ice crystals.

On a sunny day, you can observe a wide range of color on the same snowbank as morning turns to midday, afternoon, and then twilight: rose pink, orange, golden yellow, and lavender.

Overcast days are completely different, almost

The Warmth of the Winter Sun
Oil on canvas, 30 x 44" (76 x 112 cm), 1993.

In the midst of winter, a relatively warm, fifty-degree day offers a great opportunity to do some outdoor painting. Here, the "stripes" of the sunlit snow patches in the middle distance are repeated by the shadow patterns in the foreground—all echoing the vertical thrust of the tree trunks.

monochrome, for all the sky's grayness is repeated in the snow, and all the shadows disappear.

Shortly after a snowstorm, all forms are softened by a fluffy new blanket of snow. After a few days, when the snow has been warmed by sun and chilled by night, it takes on a slightly more solid, settled look, with sharper edges. Still later, dulled by dirt and dust, snow doesn't reflect light as well.

Then, late winter presents one of my favorite motifs: patches of melting snow that make abstract shapes interlocked with portions of bare earth.

Natural and Man-Made Forms

A landscape doesn't have to be limited to mountains and trees. Buildings, roads, and bridges also are commonly employed components of landscape images. But just because they are man-made forms doesn't mean they must be painted with an engineer's precision. Being products made by humans, they will automatically stand out in contrast to products made by nature. To overemphasize their differences will create a lack of unity, so the trick is to blend natural and man-made forms carefully.

Don't portray trees and rocks with exuberant organic looseness then tighten up to a rigid accuracy when rendering a nearby shed. See Wolf Kahn's *Open Studio* for a good example of how to integrate a building with landscape. This is not to say that you should paint all things the same way. On the contrary, vary your brushstrokes to add descriptive power to objects of different character. Paint a hard rock hard and a soft tent soft, maintaining their diversity, yet integrating all elements in the design.

Never forget the influence of light on all forms. The sunny side of a white building is usually lighter than the sky, but the shaded side is normally darker. Use reflected color to enhance the color variety of buildings. An organic shadow, perhaps that of a tree, falling upon the boxlike angularity of a concrete structure will tie the disparate elements together.

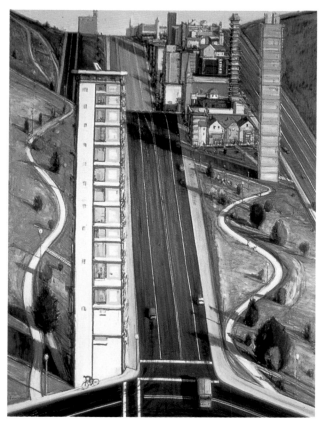

Wayne Thiebaud
Corner Apartments

Oil on canvas, 48 x 36" (122 x 91 cm), 1980. Collection of Hirshhorn Museum, Smithsonian Institution.
Although man-made forms predominate, they are painted in an organic, relaxed manner—just like the grass. Obviously, a cityscape needn't be an impersonal architectural rendering.

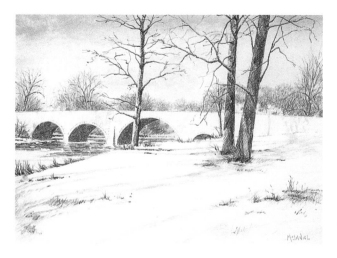

Leeds Bridge over Catskill Creek
Pencil on museum board, 9 x 11" (23 x 28 cm), 1987.

The bridge stands out because it is different, yet it is integrated with the natural elements of the scene through the overlapping of the foreground trees and some shadows that soften the bridge's right side. Furthermore, detail on the bridge is kept to a minimum so as not to compete with branches and twigs.

Historic Sites

Sometimes a commonplace scene is the most fertile ground for creating a good painting, because in choosing something anonymous, the artist thinks primarily of the compositional merit of the selection made. In depicting a site with a history, the painter must be careful not to be locked in to a design based upon fame instead of visual interest. But when they inspire artists, specific sites gain new stature.

"First *impression*, then *expression*" refers to the need for an artist to be moved by the subject. Often the psychological energy one perceives is strong at a location where some significant event occurred. For instance, I was "electrified" when I stood at the Greasy Grass (Little Big Horn) River and thought of Custer's Last Stand. Walking next to the Pont du Gard in

Alcatraz
Oil on panel, 12 x 16" (32 x 41 cm), 1996.

Alcatraz is certainly loaded with history, but I was equally attracted by the light breaking through the clouds to illuminate the buildings. The lighting seemed to accentuate the mystery of the island.

France and thinking about how it was built two thousand years ago also had a profound effect upon me.

Gettysburg or Waterloo may not be any more intrinsically paintworthy than your neighbor's backyard. But if historical presence attunes you to a site, it may sharpen your focus on the real components—shape and light—that make any site paintworthy.

Landscape areas such as Provence and the Hudson River Valley are imbued with artistic heritage. You are not only aware of famous painted images created at these places, but also are intrigued to imagine that great artists walked these paths that you now walk, or sat upon the very rock that you now touch.

Whether you are painting near Monet's gardens at Giverny, where hundreds of artists have set up their easels under the spell of the master, or are sitting at the base of the great pyramid of Khufu, your emotional response to a historical site may be the catalyst that lifts your work to new heights of passion.

Mont Saint Michel
Pastel on Wallis paper, 11 x 17" (28 x 43 cm), 1996.

This famous French landmark has been a sanctuary, a fortress, and a prison. The monastery buildings themselves date from the thirteenth century. The distinctive surrounding tidal flats are submerged during high tide, turning Mont Saint Michel into an island.

Abstracting from Nature

The basis of abstract art is the concept of responding to color and shape rather than rendering specific objects. Those painters tied to a representational context often deny themselves the opportunity to experiment with shape and color in a freely creative manner. This in no way means realistic painting cannot be compositionally creative, only that many realistic painters fail to see their paintings on any level beyond the superficial. Art relies on far more than an accurate depiction of objects in space. Good realistic painting also has good abstract structure.

As I have urged earlier, a primary means of focusing attention on form rather than photographic detail is by simplification. By stripping images bare of all but the essential, an artist concentrates more on the interaction of component parts. Landscape is unique in

Edward Betts
Crosscurrents
Acrylic, 30 x 44" (76 x 119 cm), undated. Courtesy of the artist.

The original concept of the painting focused upon an ocean theme. The image was built up with tissue paper and sandpaper, using a number of glazes, "undoing and redoing" until the composition was right, hinting at waves and sea foam. Of course, it also looks like an aerial view through clouds to a valley below, and its creator agrees that many interpretations are both possible and desirable with such generalized forms.

that a lot of simplification occurs naturally. We can't see all the leaves on a distant tree, nor can we see individual trees on a distant mountain, so we must sim-

After Acadia
Oil on canvas,
30 x 44"
(76 x 112 cm),
1980.

This is a composite image of remembered shapes and sensations from an island off the coast of Maine.

plify. There are also points where an object is just on the boundary between being clearly recognizable and merely suggested.

Increased simplification through distance is accentuated by inclement weather and atmospheric perspective. When you see a form just barely emerging from fog, its outline is pared down to the most basic of shapes, but you can still identify it.

Every landscape painting is an abstraction of some sort. After all, representing depth on a flat, two-dimensional canvas is an illusion. A landscape artist must decide what to include, what to omit, and what to transform—all of which is abstraction.

Even "realistic" landscape painting offers considerable freedom for manipulating the image. Putting an extra branch on a tree for visual balance seems almost automatic.

Additionally, the effects of changing light and mood are constantly encouraging an expressive interpretation of nature. While abstraction can apply to any subject matter, it seems to be a simple choice with landscape: deep and shallow space, the fleeting effects of wind and weather, atmospheric effects on color and form, and an artist's freedom to rearrange organic components at will.

Other Avenues for Image Making

In his *Treatise on Painting*, Leonardo da Vinci recommended examining the stains on walls or the embers in a fire as a source of inspiration, for in studying all these haphazard images, "the spirit is quickened to new inventions."

This inquisitive attitude characterized Leonardo's genius. His investigation into the nature of things was the first step in his creative process. Likewise, we should all remain constantly open and alert for potential compositional ideas.

One can look at clouds or stains and be reminded of faces or animals, or one can do quite the reverse. When I look at a landscape painting or real scene, I don't always try to identify objects. What I see first is essentially a grouping of nonrepresentational shapes. It is the arrangement of shapes that attracts me, and when painting, I'm primarily concerned with getting my compositional structure into an abstract arrangement. If the design seems satisfactory to me, I can then pay attention to rendering the objects. I never hesitate to employ "accidents" from time to time. Do the same in your work. It is your trained aesthetic sense that chooses to incorporate or discard such effects. The selection is no accident at all.

Squeaker Cove
Pigma ink, 9 x 11 1/2" (23 x 28 cm), 1996.

As I sat by the water's edge, watching the incoming waves and listening to the hypnotic surf, I began to draw—slowly at first, and then with increasing speed as the composition began to take shape. The whole process was a meditation.

Conclusion

If you look at nature intently, with the eyes of an artist, you'll find answers to most of your painting questions. They're right there in front of you. If you learn from your observations, if you become sensitive to the way things grow, and the way light falls, and you combine this knowledge with artistic insight, you can create successful landscapes.

It's not necessary to copy every detail precisely; in fact, that's usually a bad idea. But if you suggest a "sense of place" in your work, and blend it with strong composition and your own personality, you've got something worthwhile. That's what it's all about: creating a natural space, well composed, with personal significance.

When you go out to paint the landscape, observe nature with your entire soul, and respond creatively to that impression. Ask yourself what moves you when you look at the scene. Hold this in your heart, distill it, and paint with passion.

—*From a lecture given at the Lyme Academy of Fine Arts, October 1991.*

Index

Levee Light
Oil on canvas, 16 x 33" (41 x 84 cm), 1996.

The text of this book is set in Dante, a typeface cut for hand composition in 1949 at the private press of Officina Bodoni in Verona, Italy. It is based on the classical proportions of Roman carved letterforms.

The captions and headings are set in Gill Sans, designed by Eric Gill and produced by Monotype in 1928.

Edited by Robbie Capp
Designed by Wynne Patterson
Graphic production by Ellen Greene